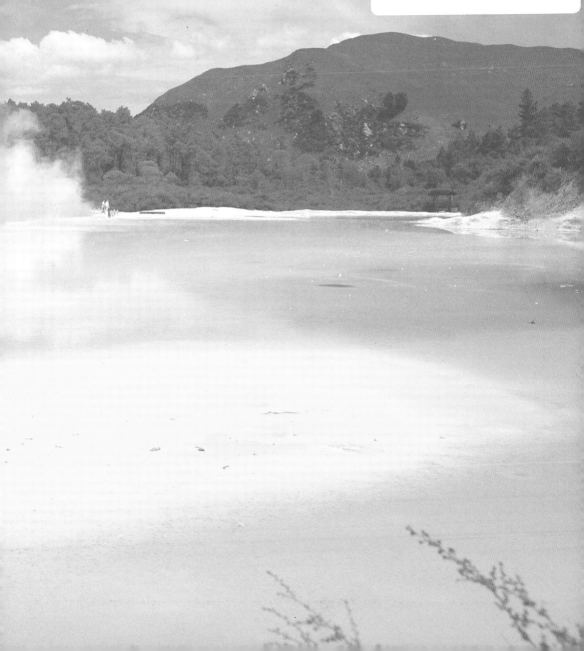

NEW ZEALAND

teNeues

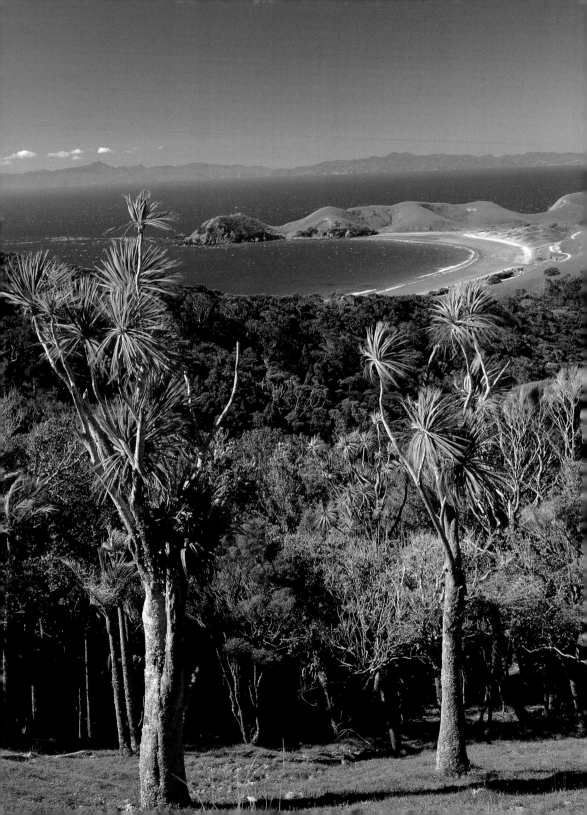

NEW ZEALAND

Photographs by Warren Jacobs
Text by John Wilson

teNeues

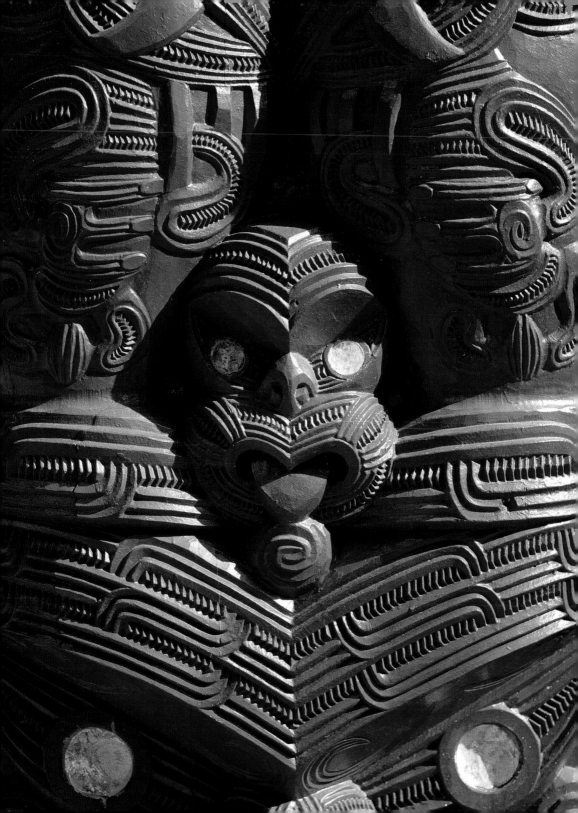

New Zealand is a lonely country. Its nearest neighbour, Australia, lies across 2000 kilometres of stormy sea. For most modern-day travelers New Zealand is the end of the line – where they turn round and head home.

Because of its distance from other lands, New Zealand was the last major habitable area on Earth to be settled by human beings. The Polynesian ancestors of today's Maori reached Aotearoa (the country's Maori name) about 800 years ago, after making daring voyages of exploration to populate the Pacific's scattered islands. In the 600 years before Europeans began arriving, the Maori evolved a distinctive culture, kept alive today by the 15 % of the population who are Maori.

The voyages of 19th century European immigrants to New Zealand were the longest single migration journeys in human history. Most of the country's 19th century settlers came from England, Ireland or Scotland. British institutions and ways of life set the pattern for New Zealand life. But in the last third of the 20th century, new settlers, especially from the Pacific Islands and Asia (each now with more than 5 % of the population), accelerated the development of a society in New Zealand that no longer copied Britain's.

New Zealand's distance from other countries also helps explain why it is lightly populated. Fewer than one million people live on the South Island. The North Island has more than three million, one third of them in Auckland. Japan, with about the same area, has twenty times New Zealand's population. New Zealand is still an open, not badly polluted, country. Areas of farmland and wilderness are almost empty of people.

New Zealand is small in area, but the two main islands are long and narrow. So the country ranges from an almost sub-tropical north to an almost sub-antarctic south. New Zealand's position astride a tectonic plate boundary gives it an extraordinary variety of landscapes. In the South Island are Alps to rival Switzerland's, lakes of continental size and fiords matching Norway's. In the North, volcanoes brood over a central plateau and geysers and hot springs break through the land's thin crust. Fine beaches abound.

But New Zealand is not all wild and empty. Cosmopolitan cities are centres of cultural life. Farms, which still earn the country much of its living, cover fertile plains or nestle among green hills. The country still has many more sheep than people!

John Wilson

Neuseeland ist einsam gelegen. 2000 Kilometer stürmische See trennen es von seinem nächstgelegenen Nachbarn Australien. Für die meisten Reisenden unserer Tage ist Neuseeland das am weitesten entfernte Ziel – hier kehren sie um und nehmen Kurs auf zu Hause.

Aufgrund seines Abstands zu anderen Ländern war Neuseeland der letzte größere Teil der Erde, der von Menschen besiedelt wurde. Die polynesischen Vorfahren der heutigen Maori erreichten Aotearoa (so heißt das Land in der Maori-Sprache) vor etwa 800 Jahren nach wagemutigen Erkundungsreisen, die zum Ziel hatten, die verstreuten Inseln im Pazifik zu besiedeln. In den 600 Jahren, bevor die ersten Europäer ankamen, entwickelten die Maori eine unverwechselbare Kultur, die heute von den 15 % der Bevölkerung am Leben erhalten wird, die Maori sind.

Die Wege der europäischen Einwanderer im 19. Jahrhundert nach Neuseeland waren die längsten individuellen Emigrationsreisen der Menschheitsgeschichte. Die meisten Siedler dieser Zeit kamen aus England, Irland und Schottland. Britische Einrichtungen und Lebensgewohnheiten wurden zum Muster für das Leben in Neuseeland. Doch im letzten Drittel des 20. Jahrhunderts kamen neue Siedler, vor allem von den Pazifischen Inseln und aus Asien (jede der beiden Gruppen stellt heute mehr als 5 % der Gesamtbevölkerung), und beschleunigten die Entwicklung einer neuen Gesellschaft in Neuseeland, die nicht mehr die britischen Verhältnisse kopierte.

Die Entfernung Neuseelands zu anderen Ländern erklärt auch seine geringe Populationsdichte. Weniger als eine halbe Million Menschen leben auf der Südinsel. Auf der Nordinsel sind es nicht mehr als drei Millionen, ein Drittel davon in Auckland. Japan, das Neuseeland flächenmäßig ungefähr entspricht, hat eine Bevölkerungszahl, die 20 Mal so hoch ist. Neuseeland ist nach wie vor ein offenes und wenig von der Umweltverschmutzung betroffenes Land. Die ländlichen Regionen und die Wildnis sind fast menschenleer.

Neuseeland ist nicht riesig, aber seine beiden Hauptinseln sind lang und schmal. So erstreckt sich das Land vom annähernd subtropischen Norden bis zum fast subantarktischen Süden. Neuseelands Lage auf der Grenze zweier tektonischer Platten bedingt eine ungewöhnliche Landschaftsvielfalt. Auf der Südinsel gibt es Alpen, die sich mit den schweizerischen messen können, Seen von kontinentaler Größe und Fjorde, die aussehen wie die in Norwegen. Im Norden sind brodelnde Vulkane über das Zentralplateau verstreut, und Geysire und heiße Quellen bahnen sich ihren Weg durch die dünne Erdkruste dieses Landes. Wunderbare Badestrände gibt es im Überfluss.

Aber Neuseeland ist nicht nur wild und leer. Seine weltoffenen Städte sind Zentren des kulturellen Lebens. Die Farmen, die dem Land noch immer einen großen Teil seines Lebensunterhalts einbringen, bedecken die fruchtbaren Ebenen oder liegen eingebettet zwischen grünen Hügeln. Noch immer gibt es in Neuseeland mehr Schafe als Menschen!

John Wilson

La Nouvelle-Zélande est un pays isolé. 2000 kilomètres de mer agitée la séparent de l'Australie, son voisin le plus proche. Pour la plupart des touristes actuels, la Nouvelle-Zélande est la destination la plus éloignée : c'est là qu'ils font demi-tour et qu'ils mettent le cap sur le chemin de la maison.

En raison de sa distance par rapport aux autres pays, la Nouvelle-Zélande fut la dernière grande partie de la Terre à être occupée par les hommes. Les ancêtres polynésiens des Maori actuels atteignirent Aotearoa (c'est ainsi que s'appelle le pays en langue Maori) il y a près de 800 ans après des voyages de reconnaissance audacieux. Leur objectif était de s'installer sur les îles dispersées dans le Pacifique. Au cours des 600 années précédant l'arrivée des premiers Européens, les Maori développèrent une culture unique qui est de nos jours maintenue en vie par les 15 % de la population qui sont Maori.

Au 19ème siècle, les parcours des émigrants européens vers la Nouvelle-Zélande furent les plus longs voyages d'émigration individuels de l'histoire de l'humanité. La plupart des colons de cette époque venaient d'Angleterre, d'Irlande et d'Ecosse. Les institutions et les modes de vie britanniques devinrent le modèle de la vie en Nouvelle-Zélande. Toutefois de nouveaux colons, pour la plupart originaires des îles du Pacifique et d'Asie (chacun des deux groupes représente aujourd'hui plus de 5 % de la population totale) s'établirent au cours du dernier tiers du 20ème siècle et accélérèrent le développement d'une nouvelle société en Nouvelle-Zélande qui ne s'inspirait plus des modes de vie britanniques.

L'éloignement de la Nouvelle-Zélande par rapport aux autres pays explique également sa faible densité de population. Moins d'un demi-million d'habitants vivent sur l'île du Sud. L'île du Nord ne compte pas plus de trois millions de personnes, dont un tiers en Auckland. Le Japon, dont la surface correspond à peu près à celle de la Nouvelle-Zélande, atteint un nombre d'habitants 20 fois plus élevé. La Nouvelle-Zélande reste un pays ouvert et peu concerné par la pollution de l'environnement. Les régions rurales et la contrée sauvage sont presque inhabitées.

La Nouvelle-Zélande n'est pas immense, mais ses deux îles principales sont longues et étroites. Le pays s'étend ainsi du nord quasiment subtropical au sud presque subantarctique. La position de la Nouvelle-Zélande, située à la limite de deux plaques tectoniques, offre une diversité inhabituelle du paysage. Sur l'île du Sud se trouvent les Alpes, qui peuvent concurrencer avec les Alpes suisses, des lacs de taille continentale et des fjords semblables à ceux de Norvège. Dans le Nord, des volcans bouillonnants sont dispersés sur le plateau central, et des geysers et des sources chaudes se créent un chemin à travers la fine croûte terrestre de ce pays. On y trouve de merveilleuses plages en abondance.

Mais la Nouvelle-Zélande n'est pas seulement sauvage et vide. Ses villes ouvertes au monde sont des centres de la vie culturelle. Les exploitations agricoles, qui contribuent encore en grande partie au fonctionnement économique du pays, recouvrent les plaines fertiles ou sont encastrées dans les collines vertes. En Nouvelle-Zélande, on rencontre encore plus de moutons que d'hommes !

John Wilson

Nueva Zelanda es un país apartado. 2.000 km de agitado océano lo separan de su vecino, Australia. Para la mayoría de los viajeros de nuestros días, Nueva Zelanda es el destino más alejado, la última estación de su viaje.

La distancia que le separa de los demás países hizo que Nueva Zelanda fuera la última gran superficie de la Tierra en ser colonizada por los hombres. Los antepasados polinesios de los maorí llegaron a Aotearoa (el nombre del país en la lengua maorí) hace aproximadamente 800 años, después de audaces expediciones que tenían como objetivo colonizar las diseminadas islas del Pacífico. Durante los siguientes 600 años, antes de la llegada de los primeros europeos, los maorí desarrollaron una cultura inconfundible que el 15 % de la población, el porcentaje maorí, mantiene hoy viva.

Las rutas que los inmigrantes europeos siguieron en el siglo XIX para llegar hasta Nueva Zelanda, fueron los viajes migratorios individuales más largos de la historia de la humanidad. La mayor parte de los colonizadores de esa época provenían de Inglaterra, Irlanda y Escocia. Las instituciones y el modo de vida británicos se convirtieron en el modelo de vida en Nueva Zelanda. En el último tercio del siglo XX, sin embargo, llegaron al país colonos de las islas del Pacífico y de Asia (en la actualidad cada uno de estos grupos representa el 5 % de la población total). Su presencia aceleró el desarrollo de una nueva sociedad alejada ya de los modelos británicos.

La distancia de Nueva Zelanda con los demás países explica también su escasa densidad demográfica. Menos de medio millón de personas habitan la isla del Sur. En la isla del Norte, los habitantes no son más que tres millones, y un tercio de ellos vive en Auckland. La población de Japón, un país con una extensión similar a la de Nueva Zelanda, es 20 veces superior. Nueva Zelanda sigue siendo un país abierto apenas afectado por la contaminación medioambiental. En las regiones rurales y la selva apenas hay habitantes.

Nueva Zelanda no es un país de grandes dimensiones, pero la forma alargada y estrecha de sus dos islas principales hace que se extienda desde el norte casi subtropical hasta el sur casi subantártico. Su situación en el borde de dos placas tectónicas es la causa de la extraordinaria variedad de su paisaje. En la isla del Sur encontramos un paisaje alpino similar al de Suiza, lagos de tamaño continental y fiordos parecidos a los de Noruega. En la isla del Norte, la meseta central está salpicada de gorgoteantes volcanes, y los géiseres y las fuentes de agua caliente se abren camino a través de la fina corteza de este país. También abundan playas maravillosas.

Pero Nueva Zelanda no es sólo un país salvaje y vacío. Sus ciudades abiertas al mundo son los centros de la vida cultural. Las granjas, la mayor fuente de ingresos del país, cubren las superficies fértiles o se encuentran encajadas entre verdes colinas. ¡En Nueva Zelanda sigue habiendo más ovejas que personas!

John Wilson

La Nuova Zelanda occupa una posizione solitaria. 2000 chilometri di mare burrascoso la separano dal suo vicino più prossimo, l'Australia. Ai giorni nostri, la maggior parte dei viaggiatori considera la Nuova Zelanda la meta più lontana, il punto in cui rivoltare e fare rotta verso casa.

Per via della sua distanza dagli altri paesi, la Nuova Zelanda è stata l'ultima parte di terra di una certa grandezza ad essere colonizzata. Gli antenati polinesiani degli odierni Maori raggiunsero Aotearoa (così viene chiamato il paese nella lingua Maori) circa 800 anni fa, dopo audaci viaggi di esplorazione allo scopo di colonizzare le isole sparpagliate del Pacifico. Nei 600 anni precedenti l'arrivo dei primi europei, i Maori svilupparono una cultura inconfondibile, oggi tenuta in vita dal 15 % della popolazione, costituita da Maori.

I viaggi degli immigrati europei verso la Nuova Zelanda nel XIX secolo rappresentarono i viaggi di emigrazione individuali più lunghi della storia dell'umanità. La maggior parte dei colonizzatori di questo periodo proveniva dall'Inghilterra, dall'Irlanda e dalla Scozia. Le istituzioni e le abitudini britanniche divennero il modello di vita della Nuova Zelanda. Nell'ultimo terzo del XX secolo, tuttavia, giunsero nel paese nuovi colonizzatori, provenienti soprattutto dalle Isole del Pacifico e dall'Asia (ciascun gruppo rappresenta oggigiorno oltre il 5 % della popolazione complessiva), che accelerarono in Nuova Zelanda lo sviluppo di una nuova società non più fatta a somiglianza del modello britannico.

La lontananza della Nuova Zelanda da altri paesi spiega anche la sua scarsa densità. Sono meno di mezzo milione le persone che vivono nell'Isola del Sud; nell'Isola del Nord gli abitanti non superano i tre milioni, di cui un terzo ad Auckland. Il Giappone, la cui superficie corrisponde all'incirca a quella della Nuova Zelanda, ha un numero di abitanti venti volte superiore. Oggi come allora la Nuova Zelanda è un paese aperto e poco colpito dall'inquinamento ambientale. Le regioni rurali e i luoghi selvaggi sono pressoché spopolati.

La Nuova Zelanda non è immensa, le sue due isole maggiori sono tuttavia lunghe e strette. Il paese si estende pertanto da un nord pressappoco subtropicale ad un sud quasi subantartico. La posizione della Nuova Zelanda sul confine tra due placche tettoniche determina l'insolita varietà paesaggistica del paese. L'Isola del Sud presenta Alpi paragonabili a quelle svizzere, laghi di dimensioni continentali e fiordi simili a quelli norvegesi. Al nord ci sono vulcani attivi sparpagliati sull'altipiano centrale, mentre geyser e sorgenti di fanghi ribollenti si fanno strada attraverso la sottile crosta terrestre di questo paese. La Nuova Zelanda abbonda anche di stupende spiagge balneari.

La Nuova Zelanda non è però solo selvaggia e spopolata. Le sue città cosmopolite sono centri di vita culturale. Le fattorie, che rappresentano ancora una delle principali fonti di sostentamento per il paese, ricoprono le fertili pianure o spuntano tra verdi colline. In Nuova Zelanda, in fondo, ci sono ancora più pecore che uomini!

John Wilson

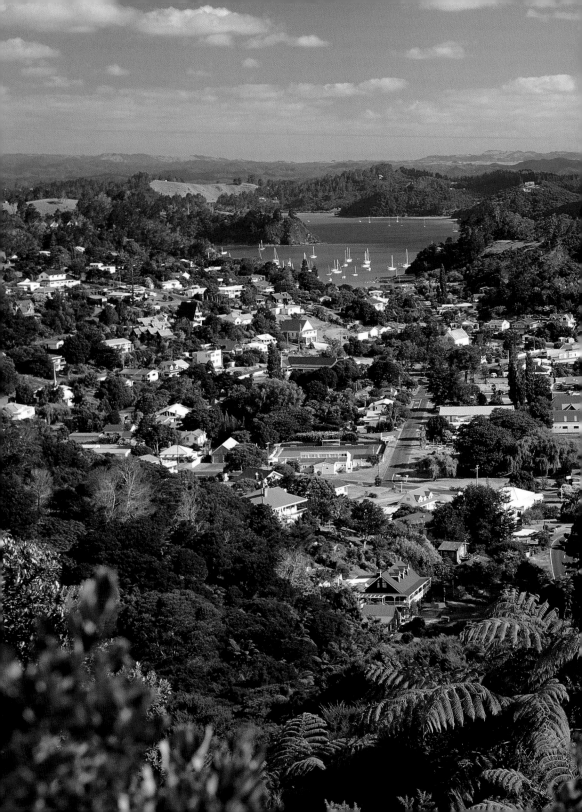

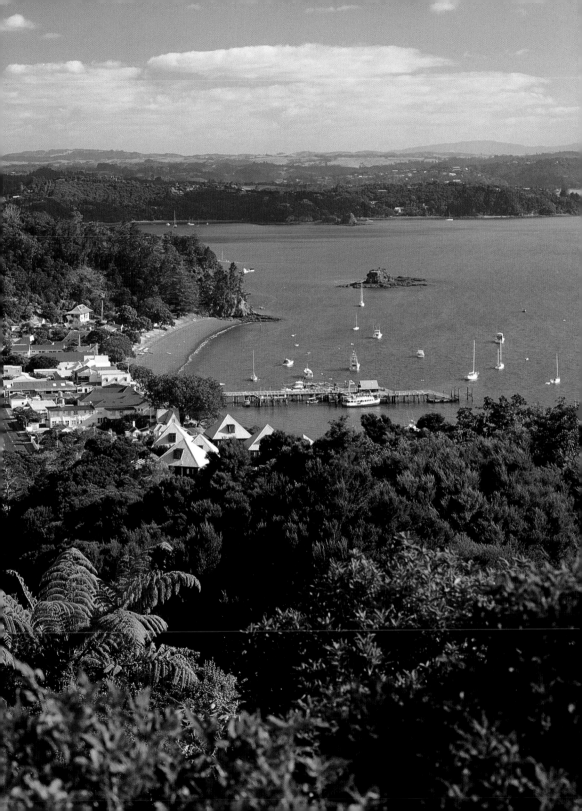

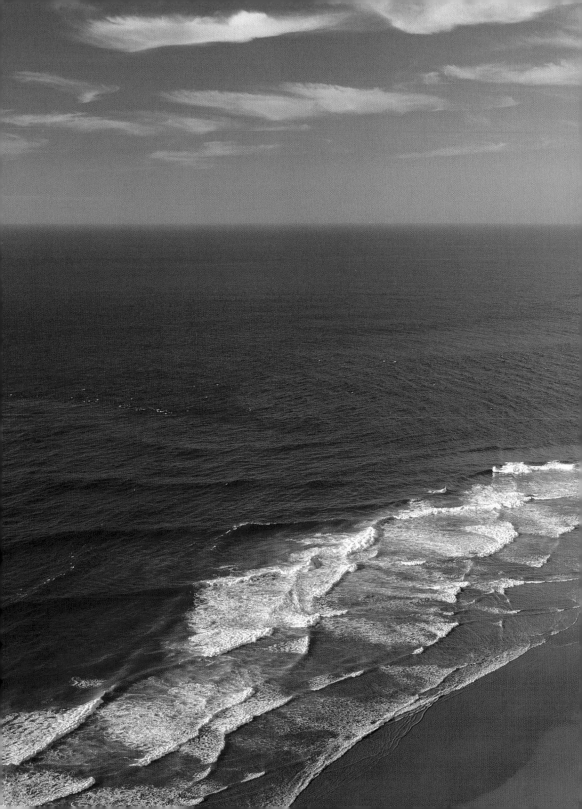

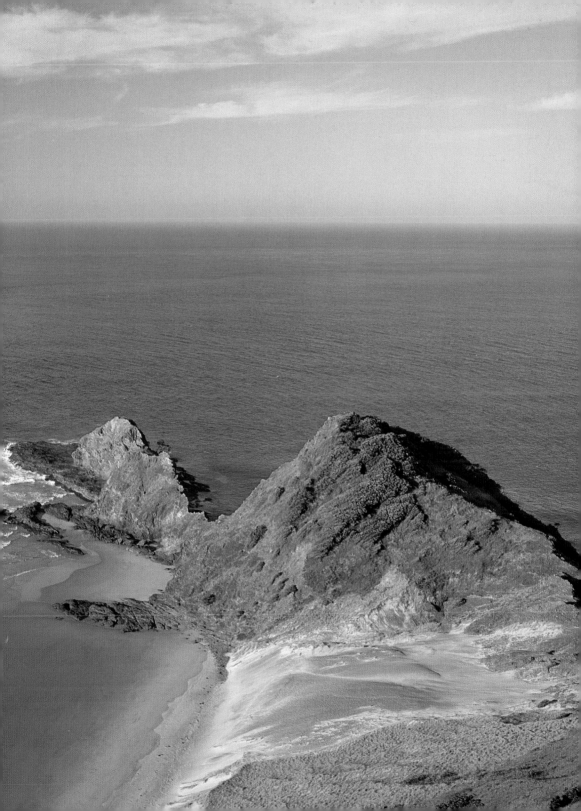

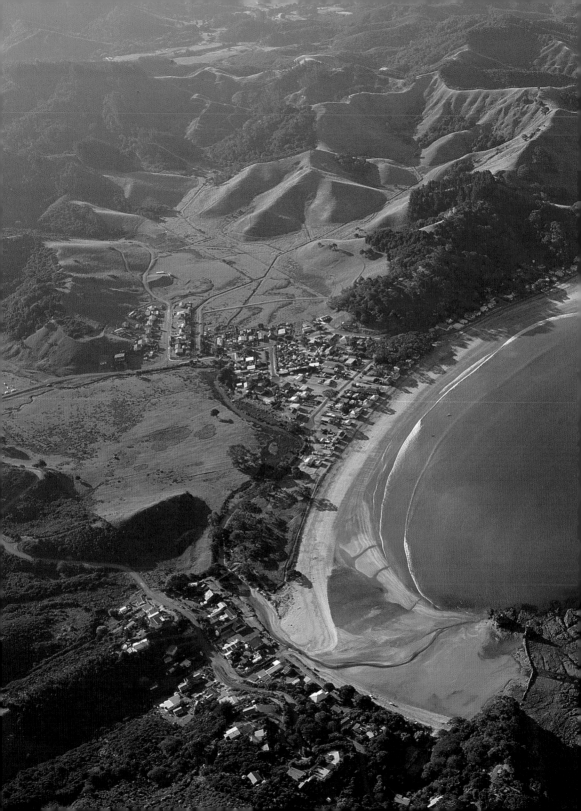

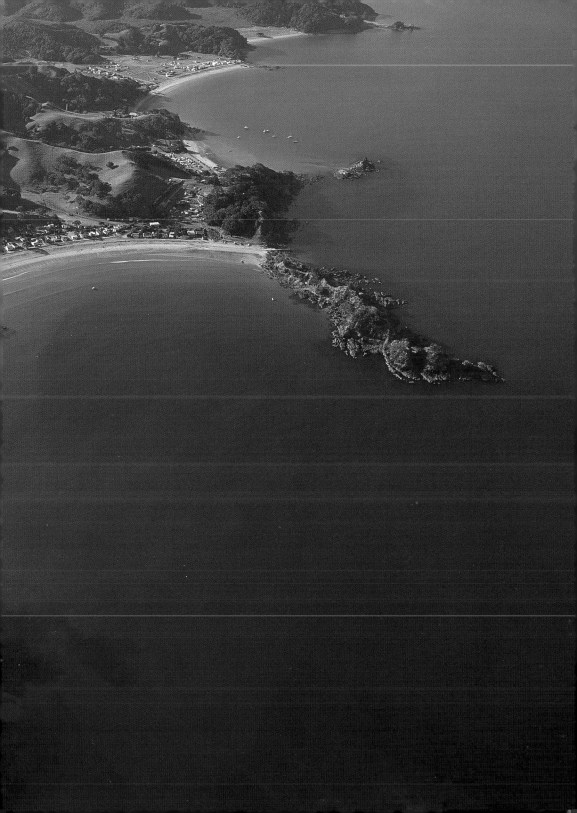

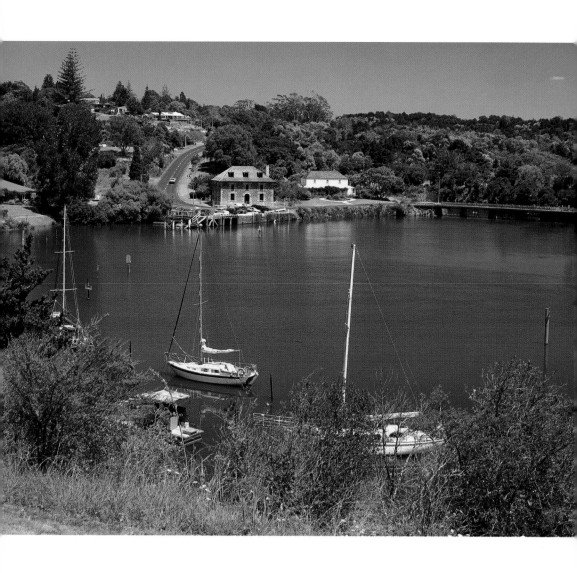

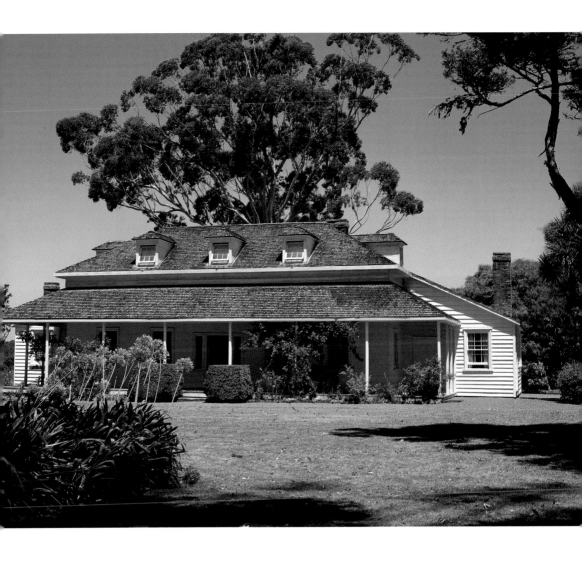

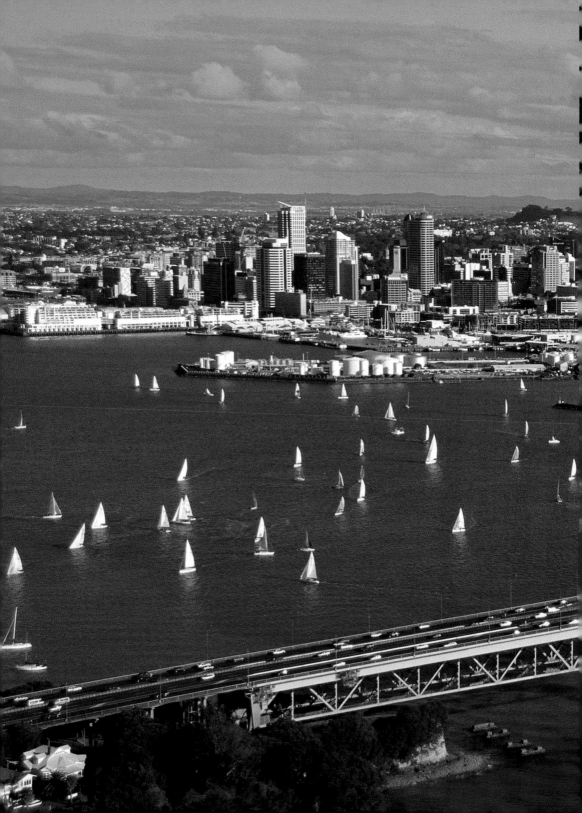

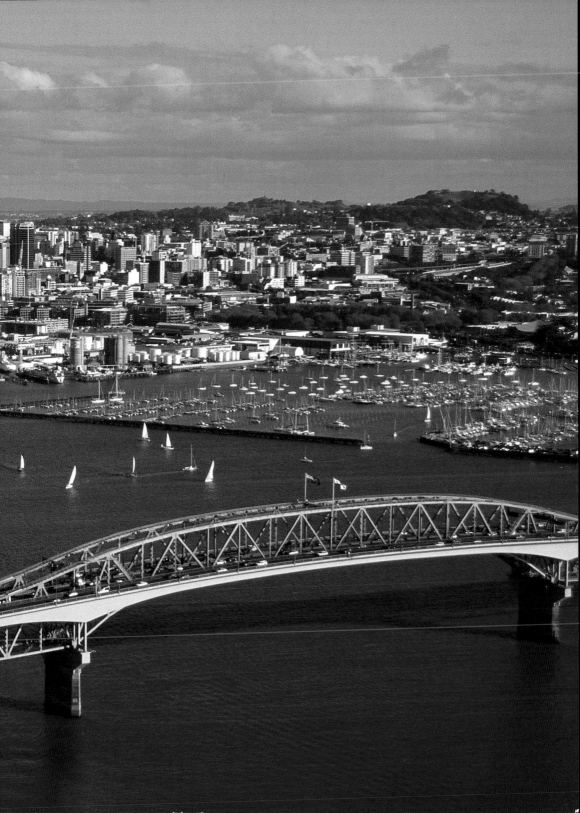

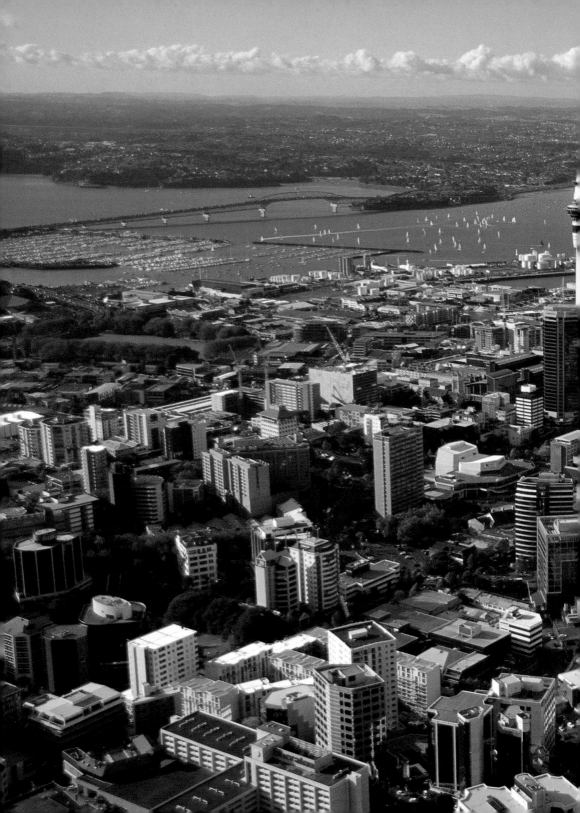

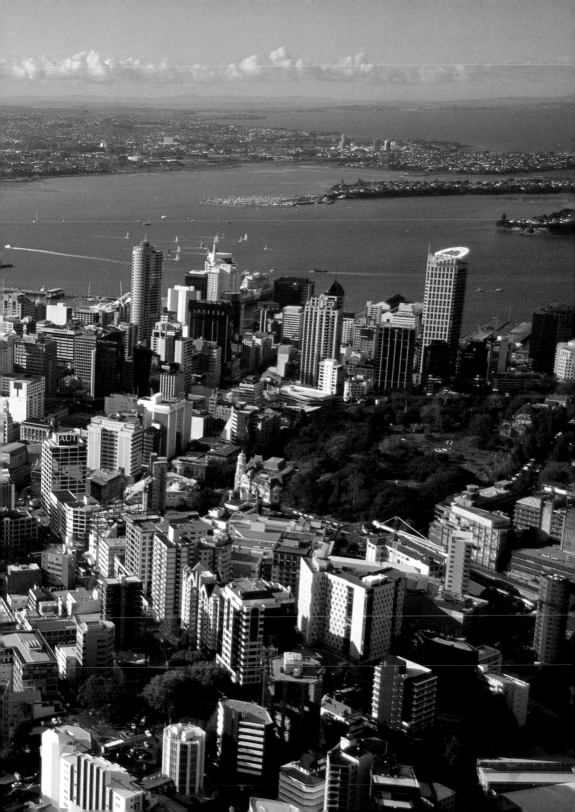

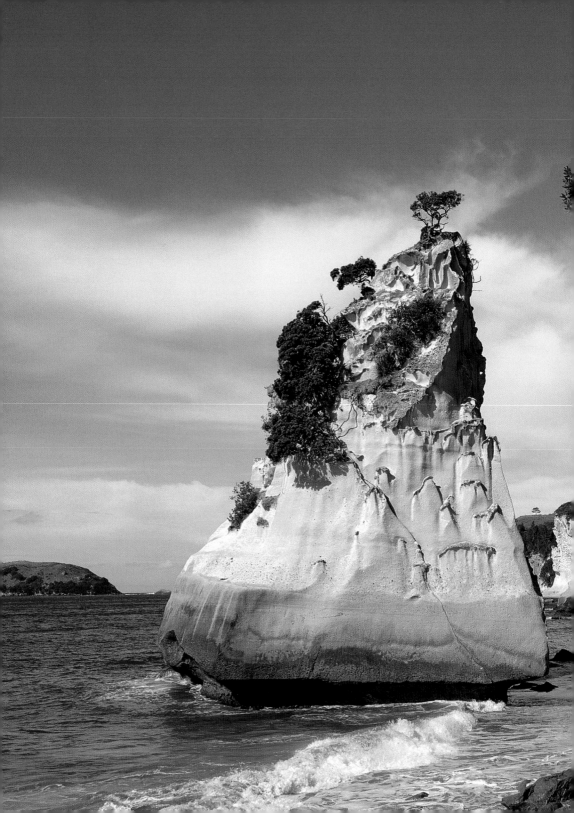

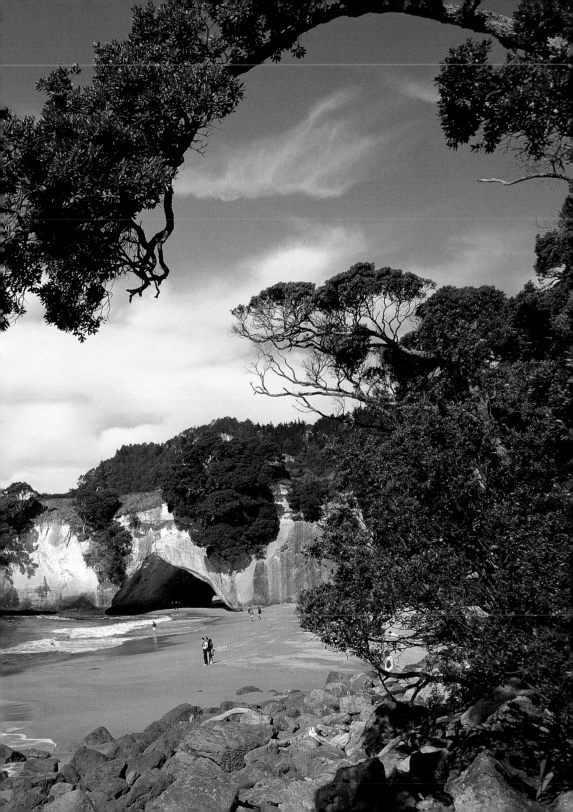

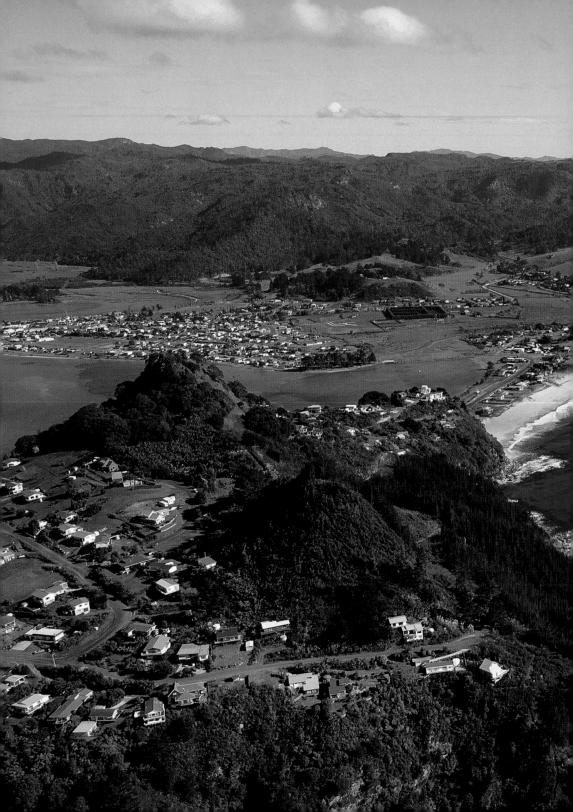

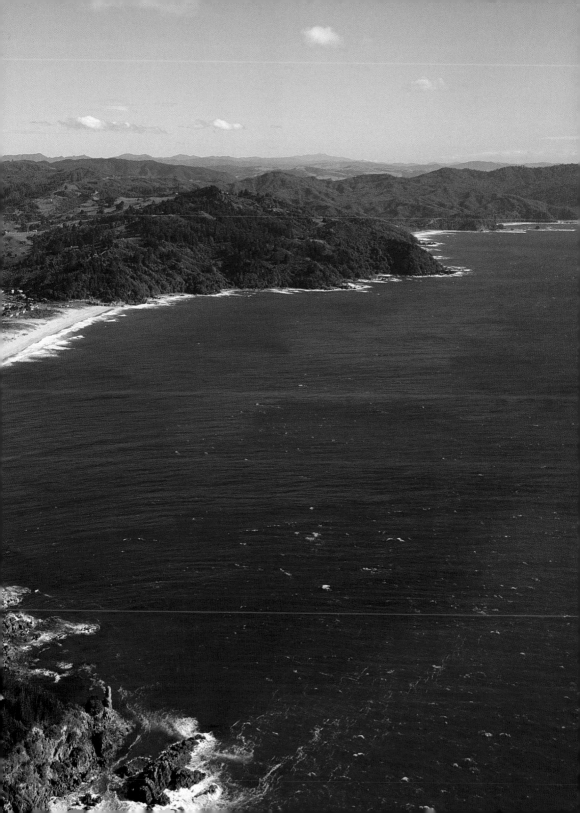

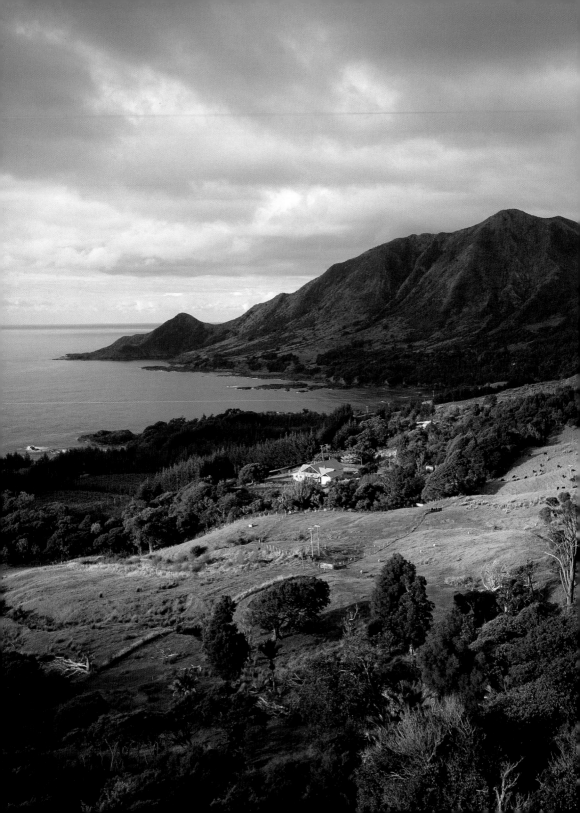

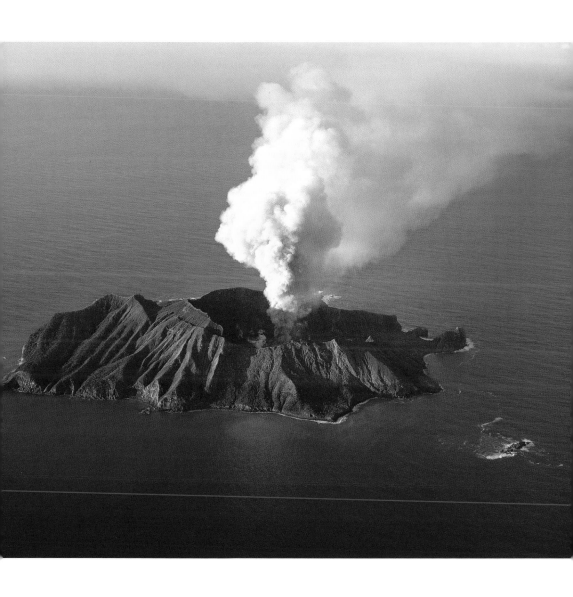

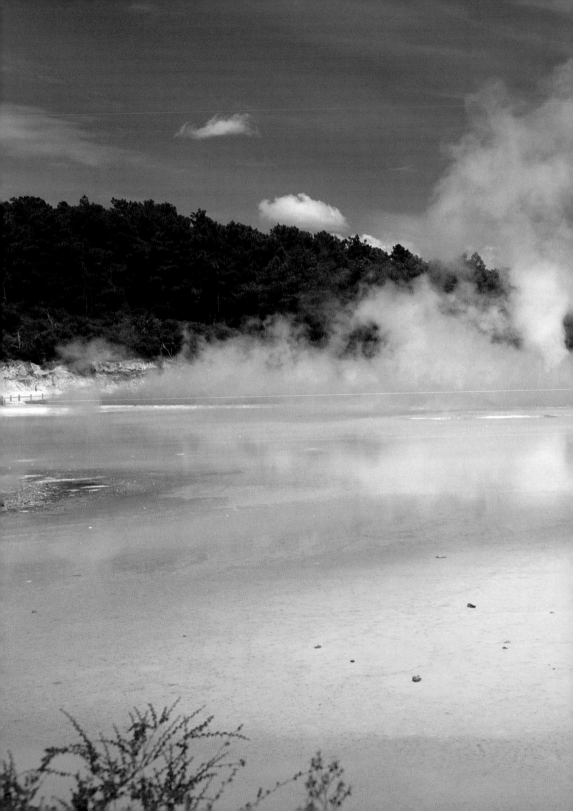

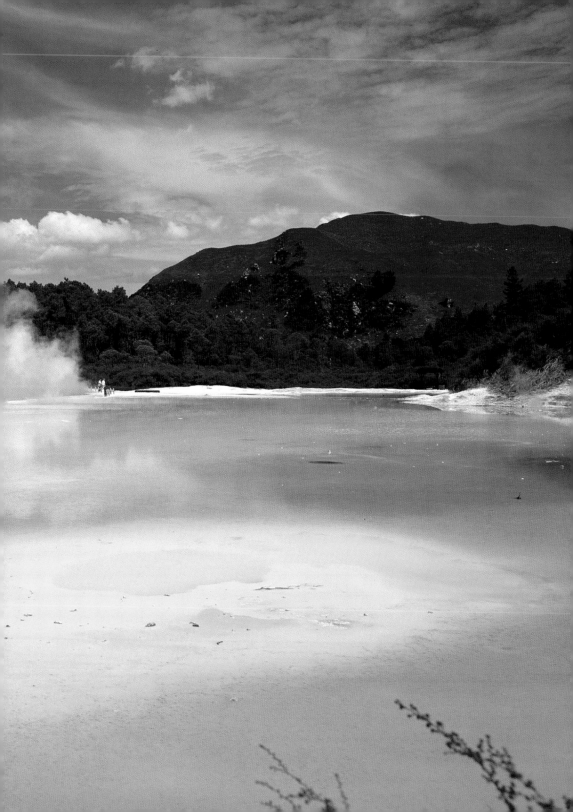

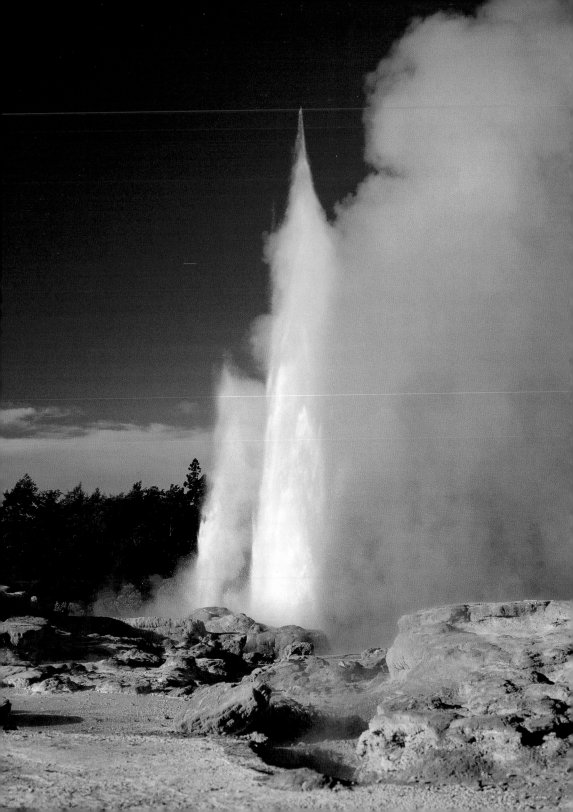

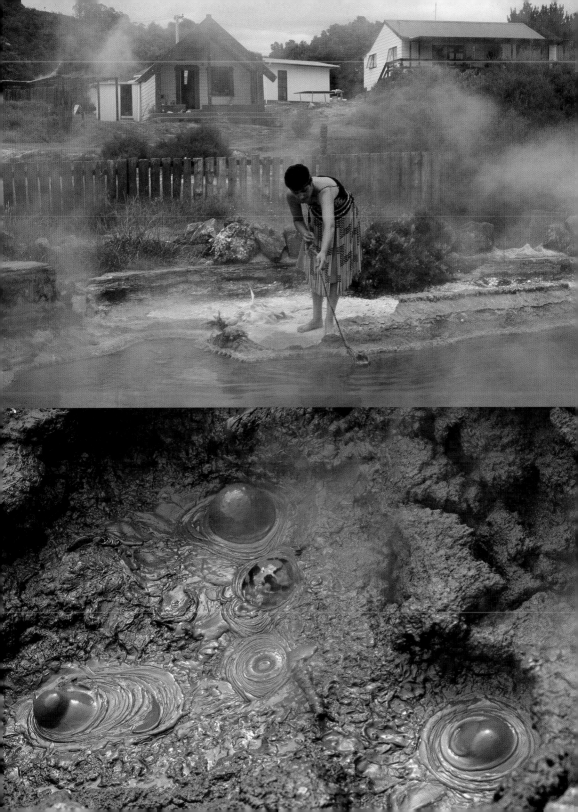

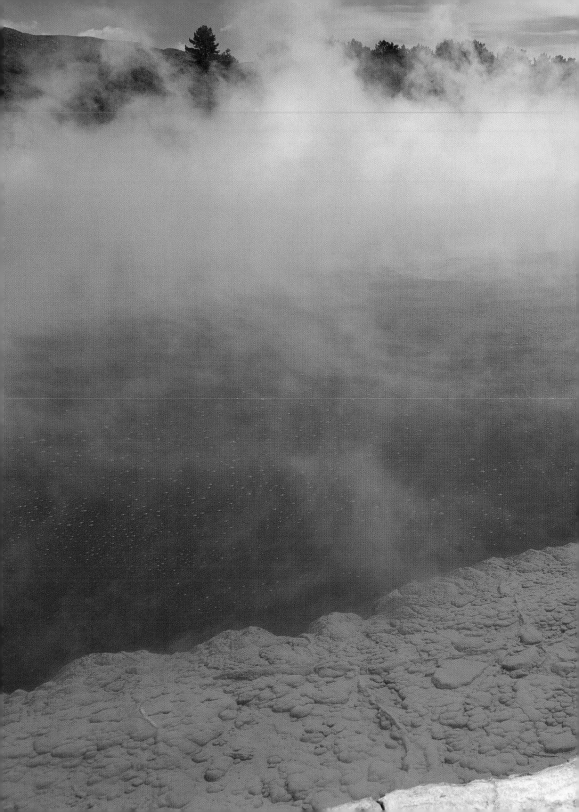

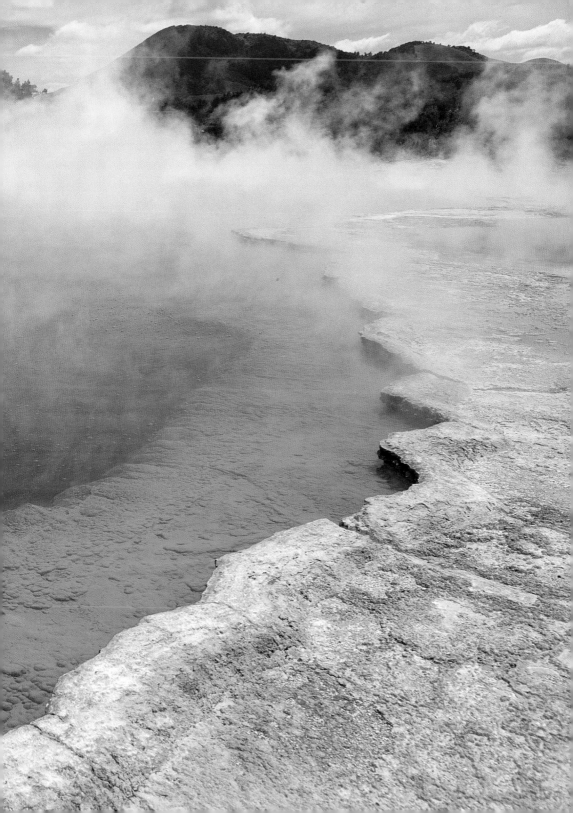

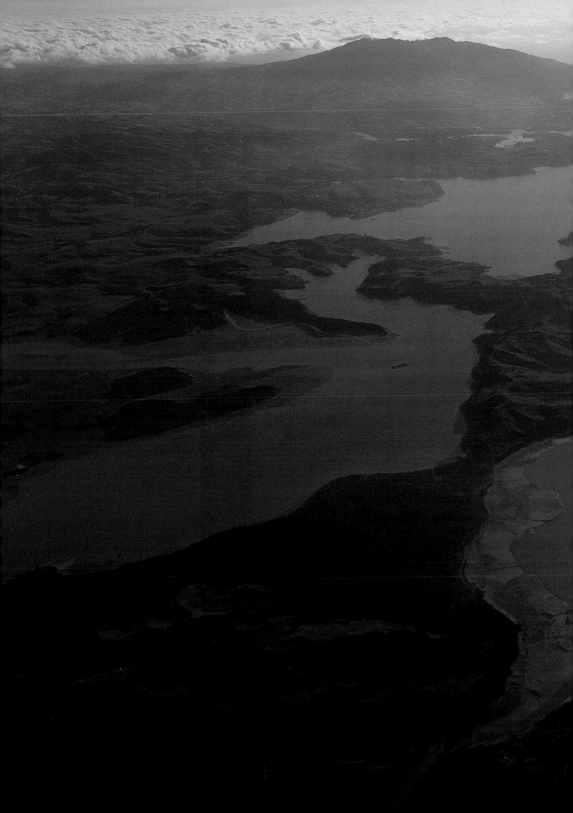

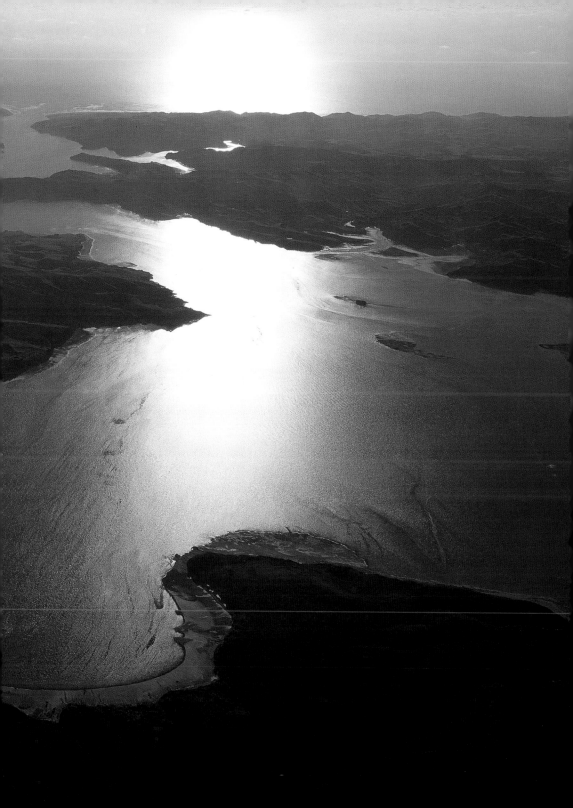

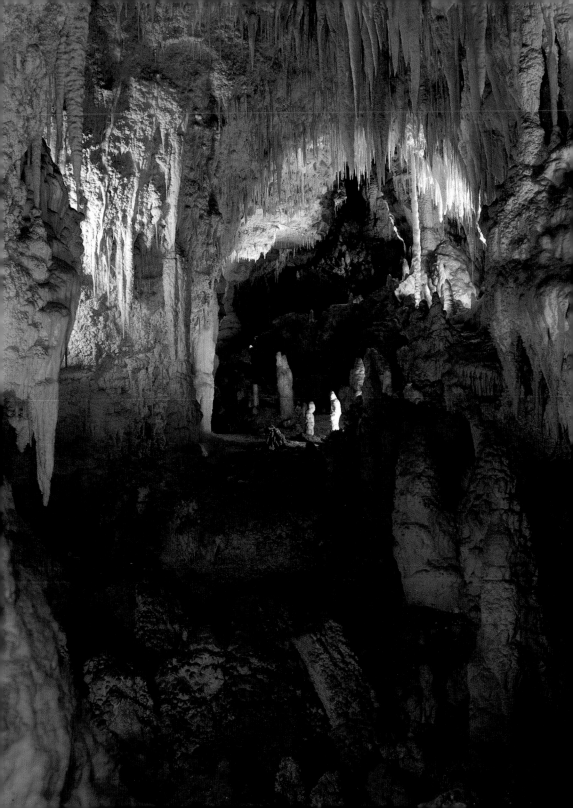

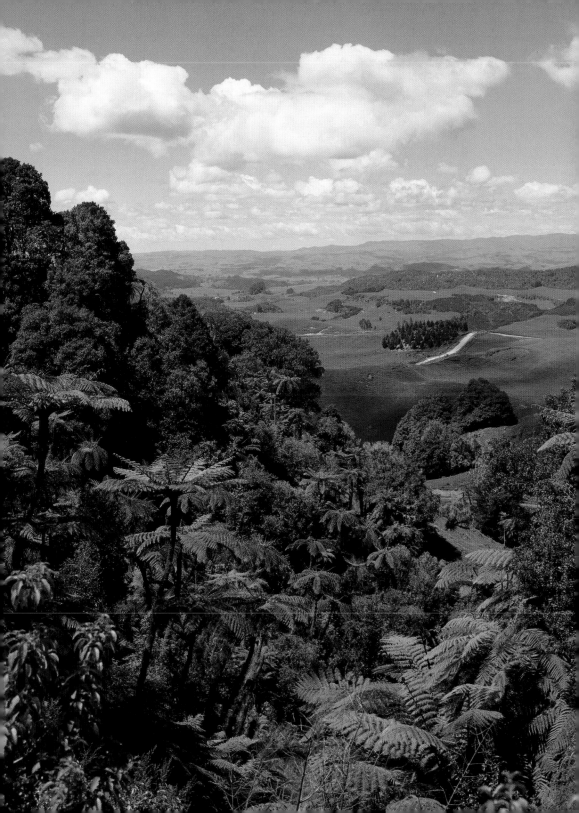

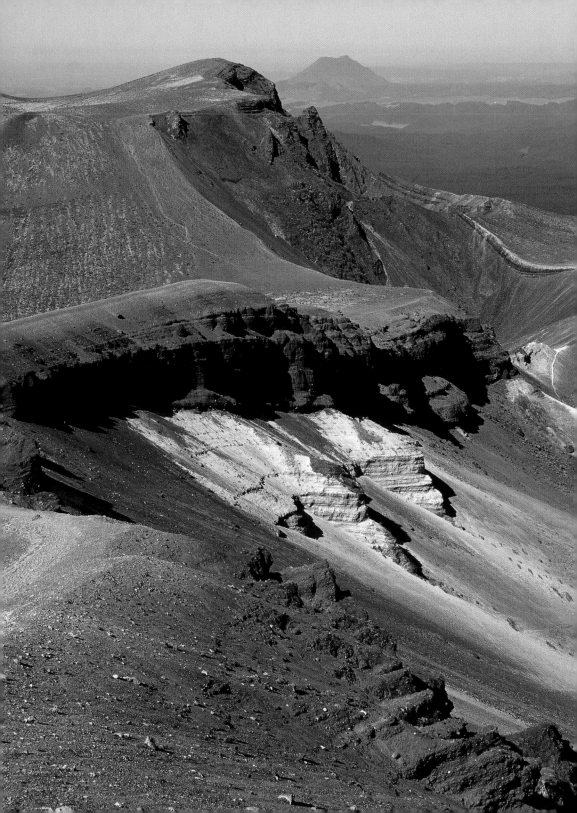

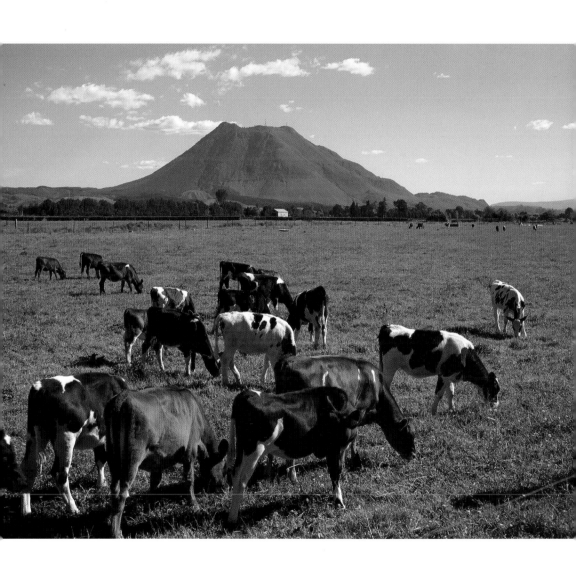

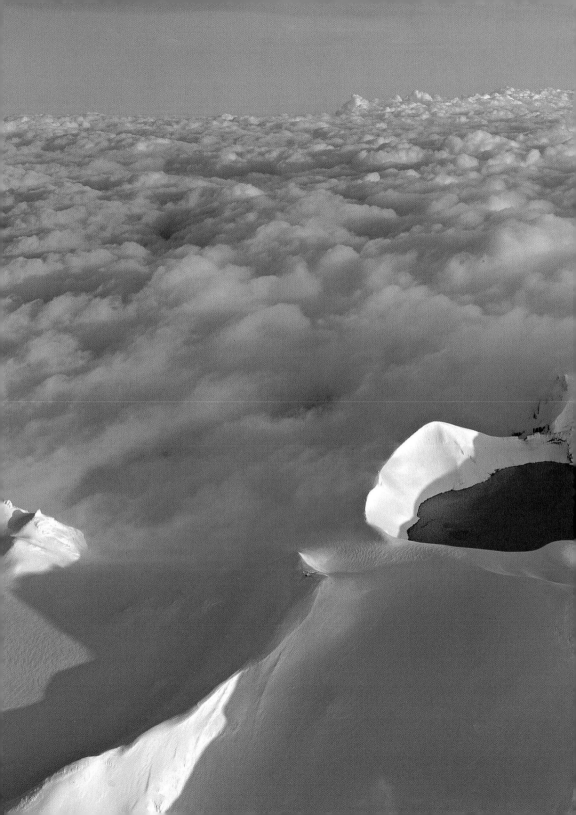

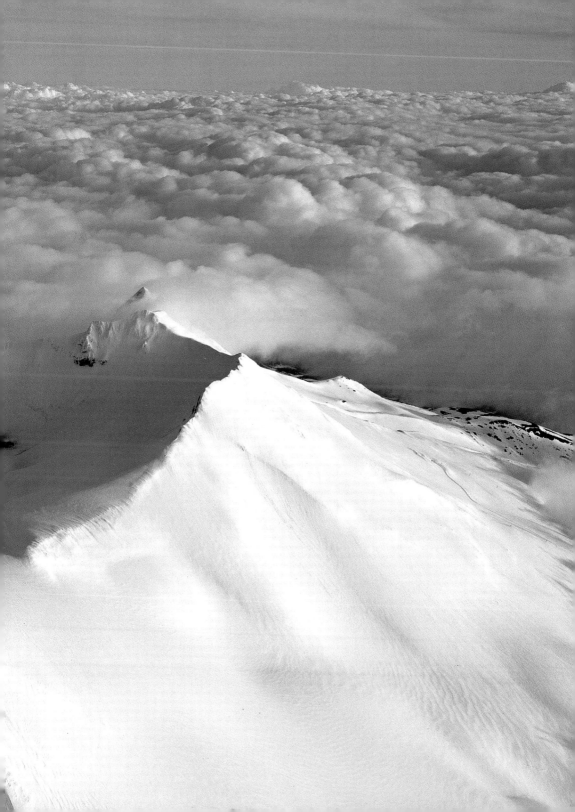

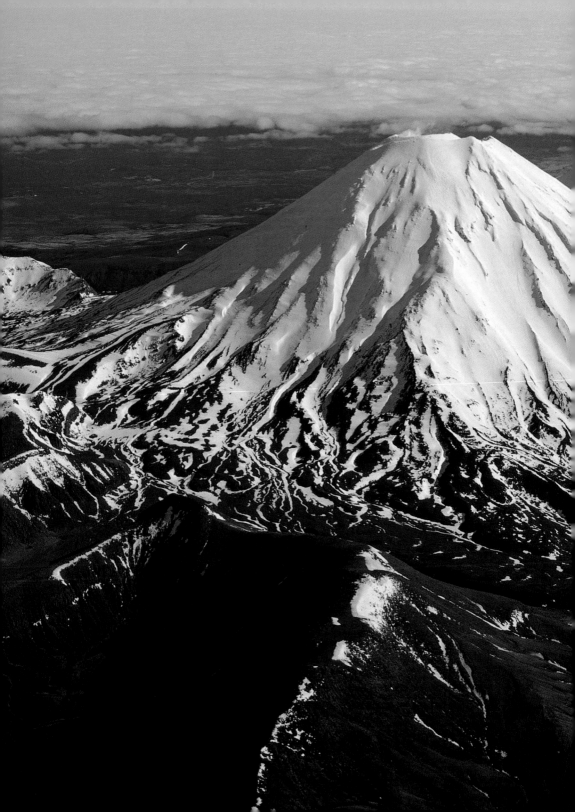

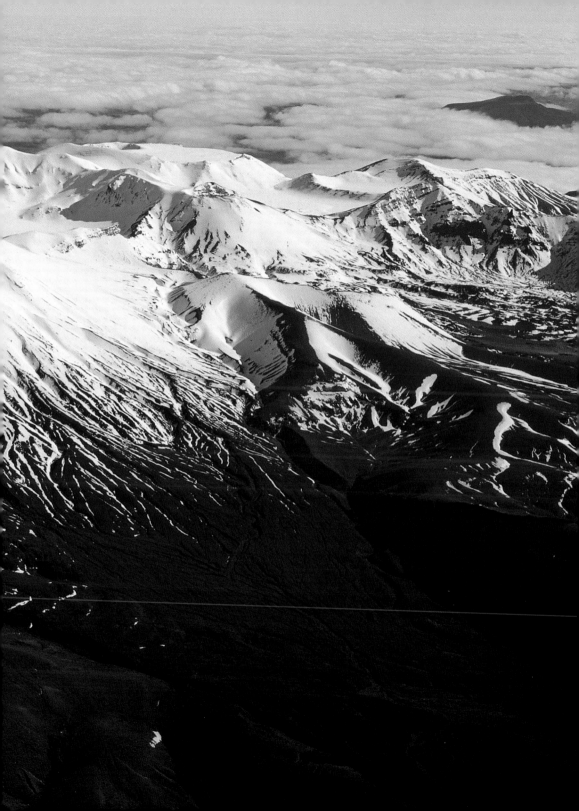

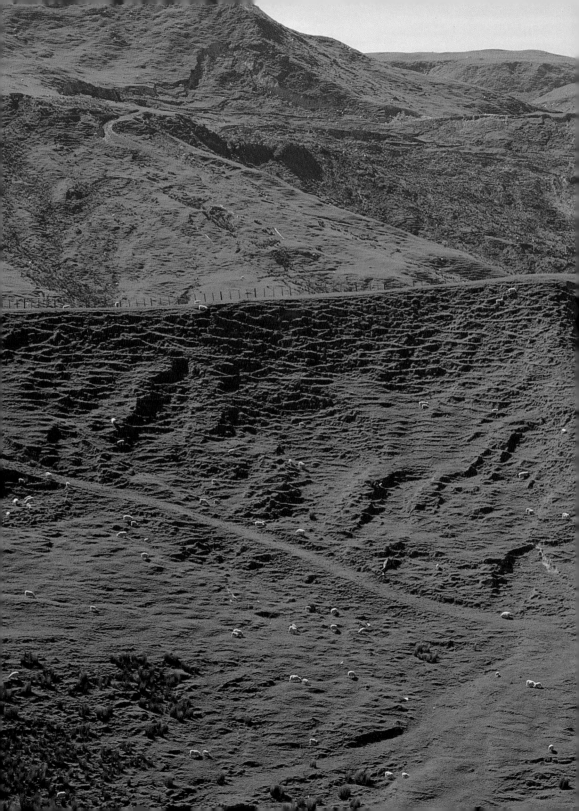

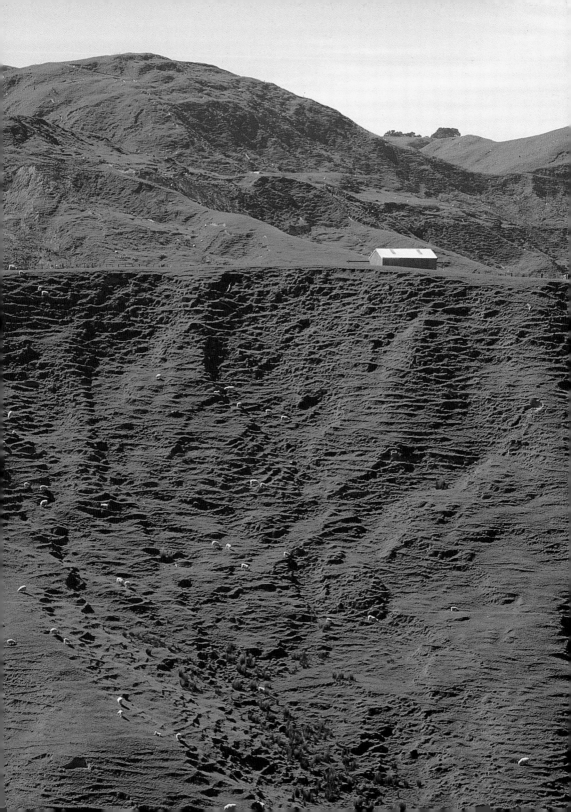

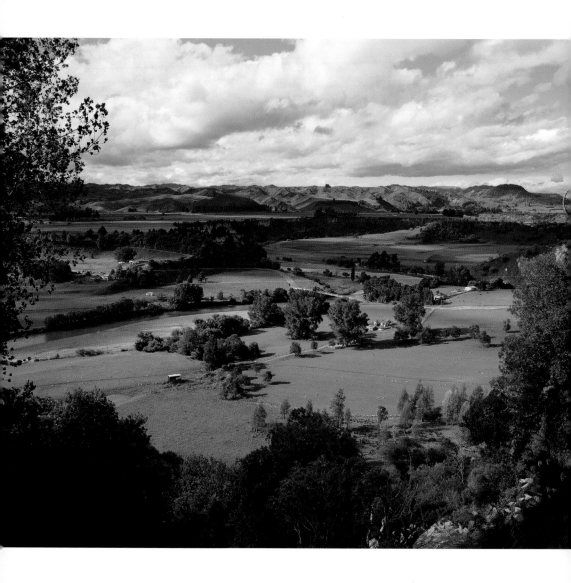

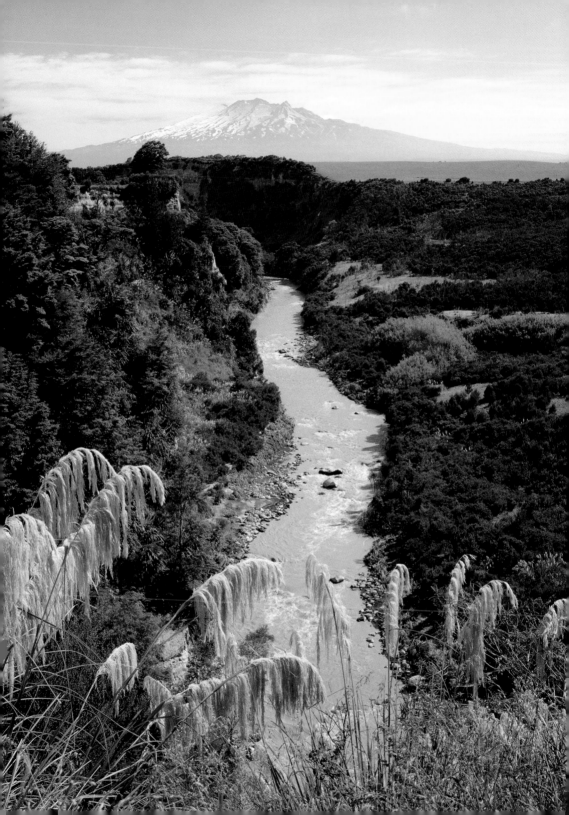

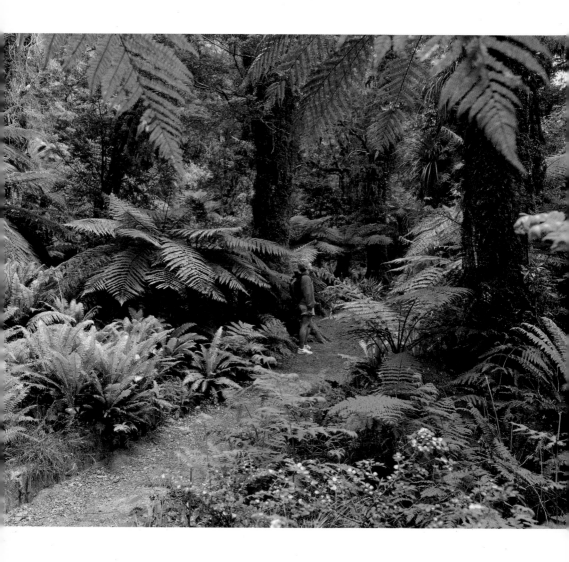

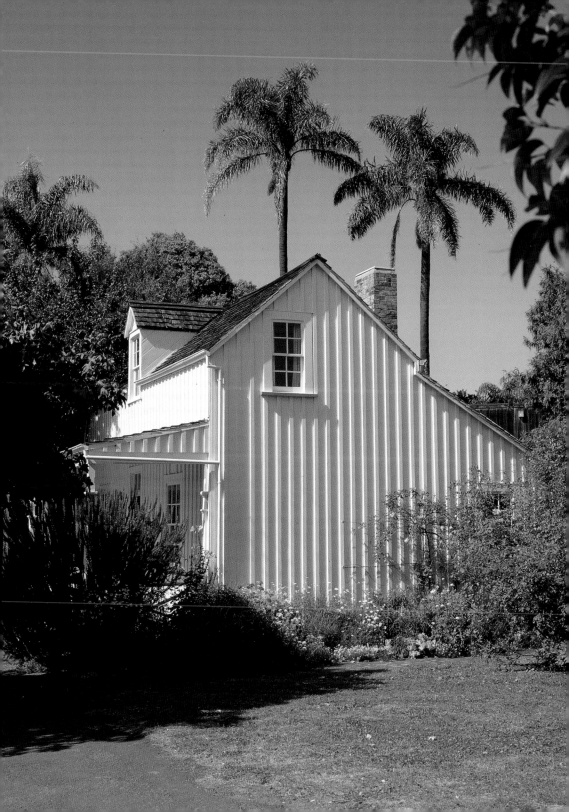

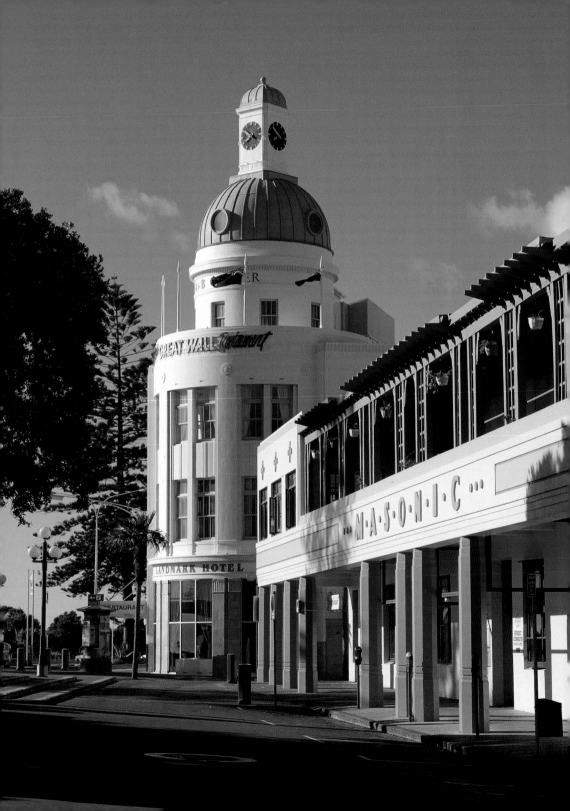

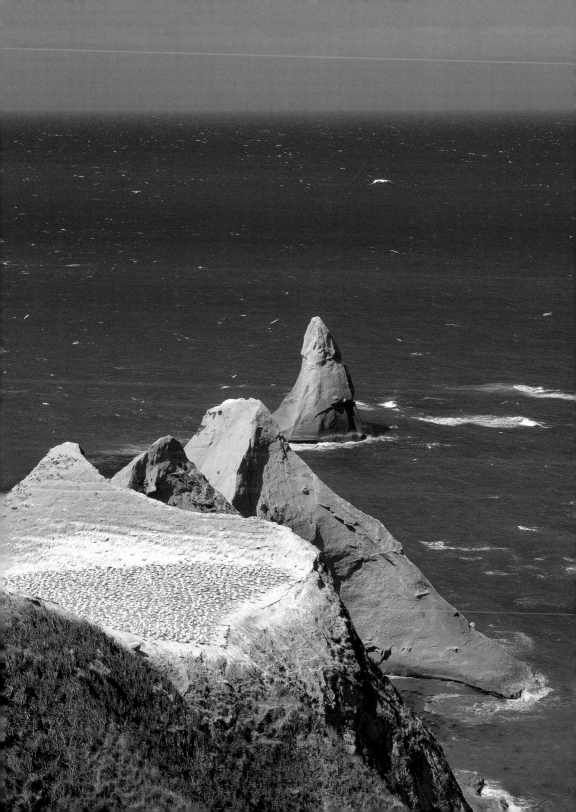

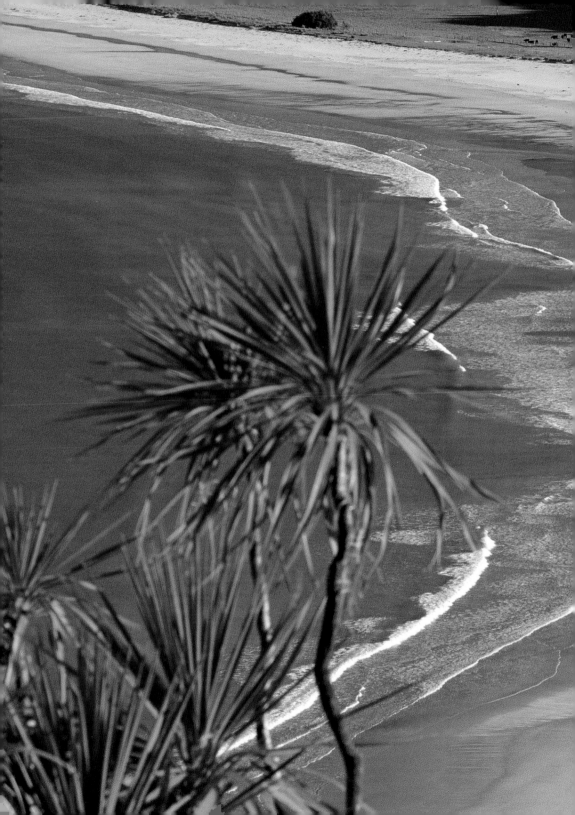

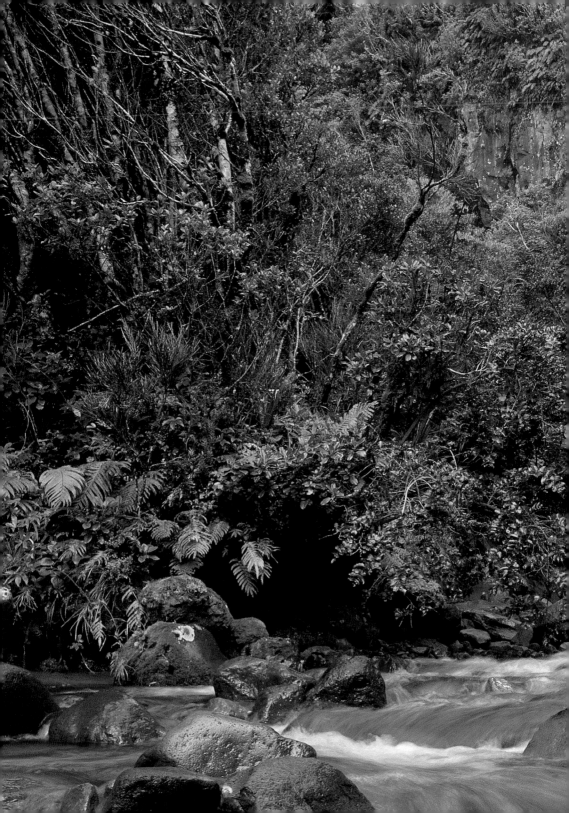

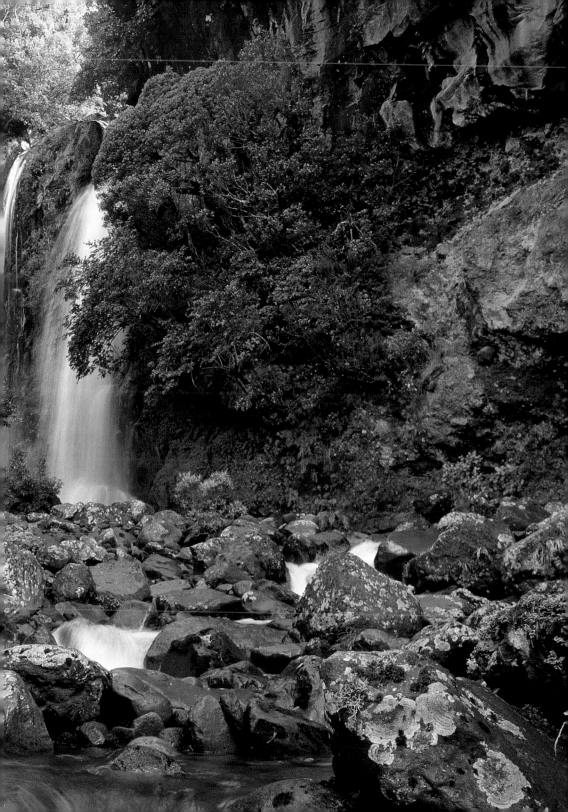

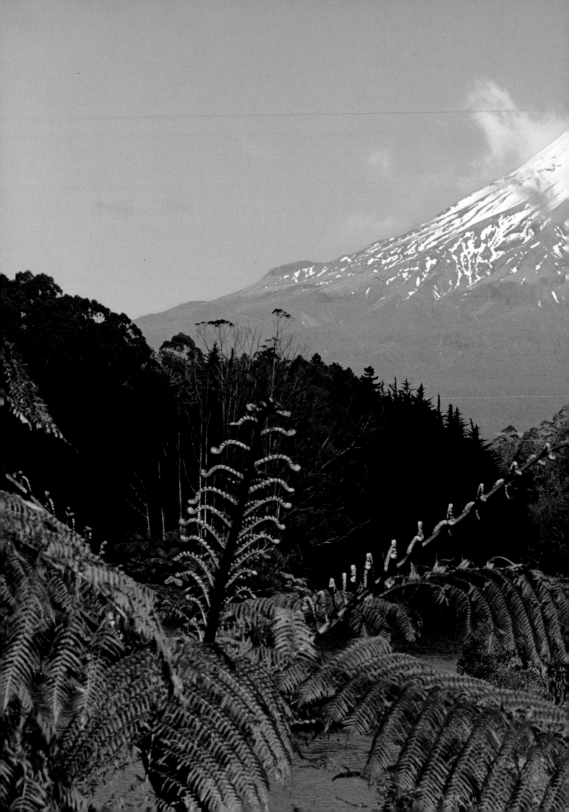

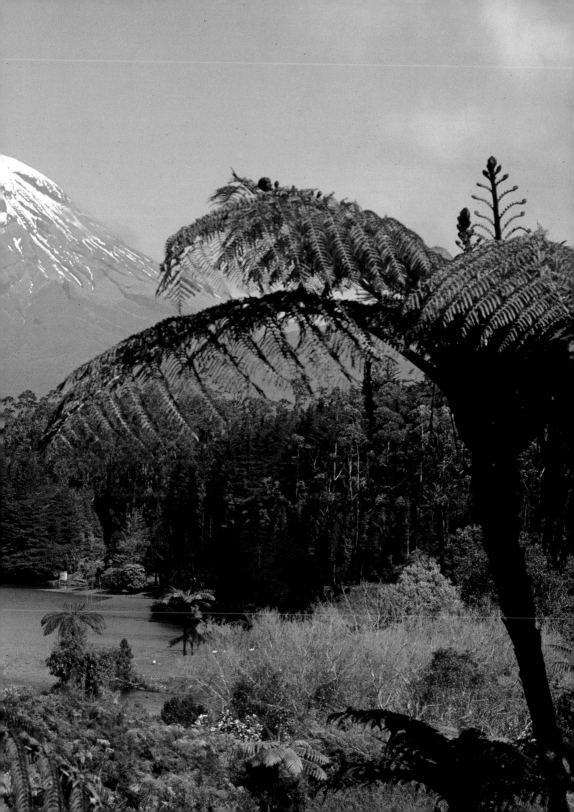

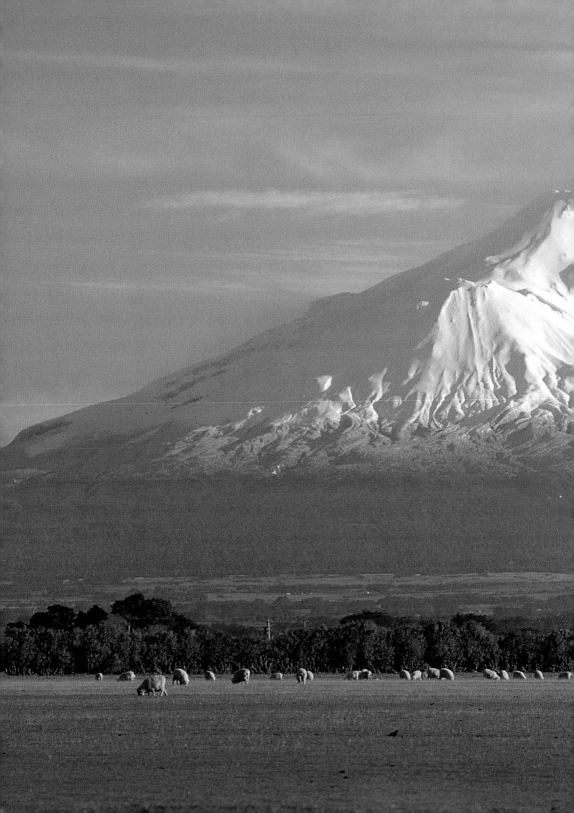

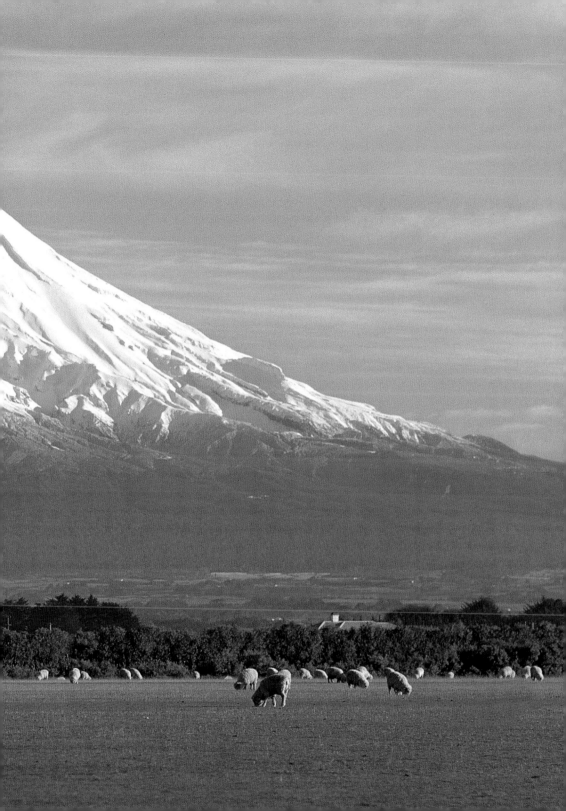

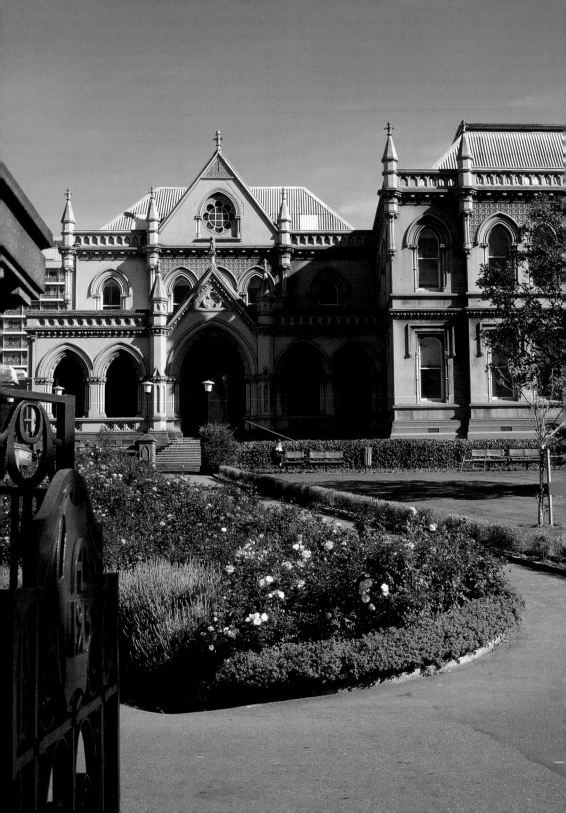

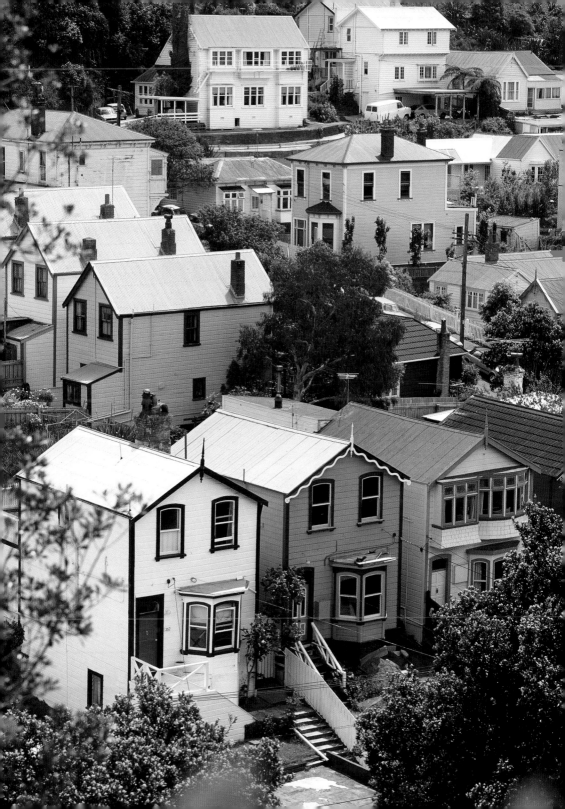

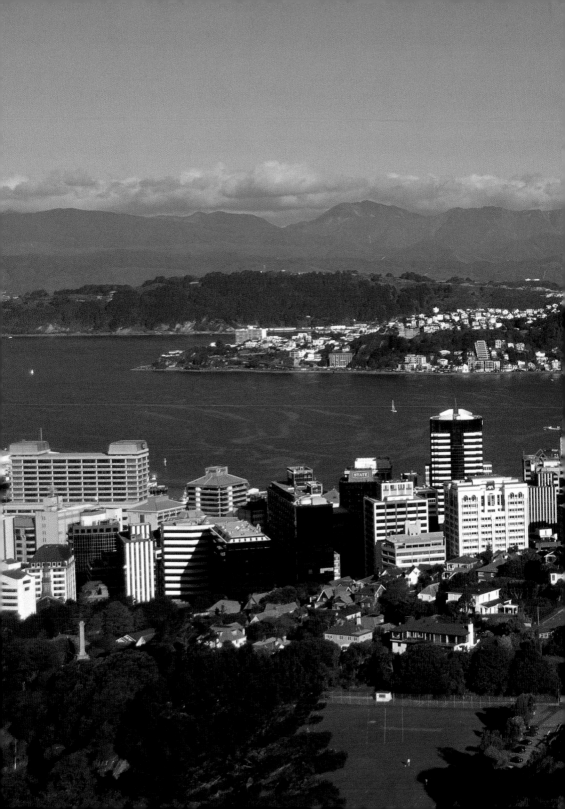

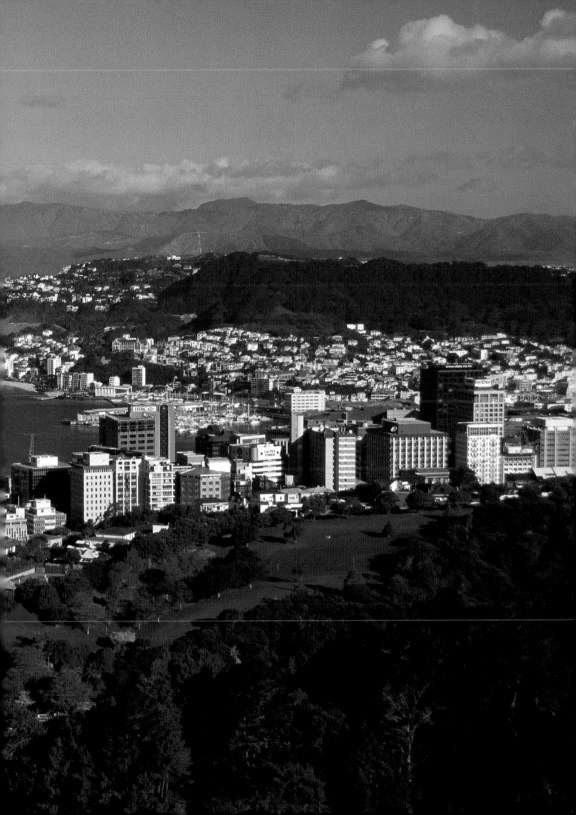

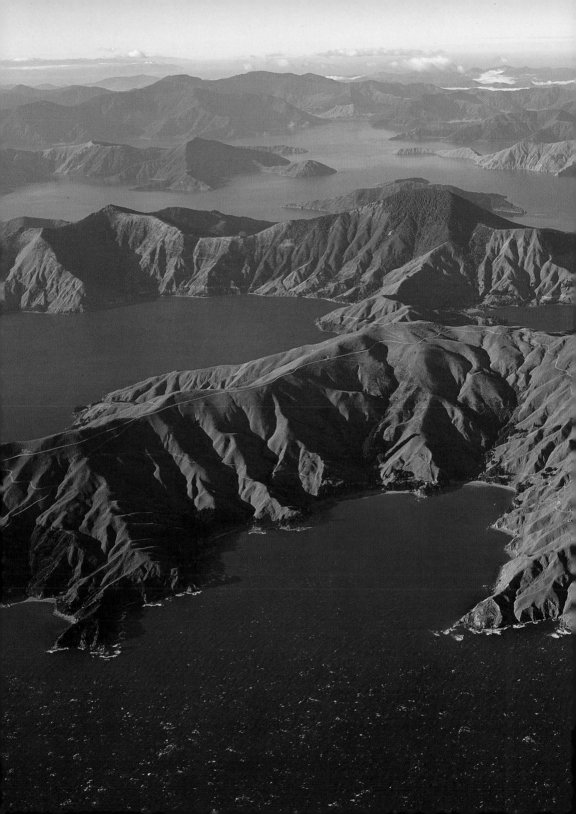

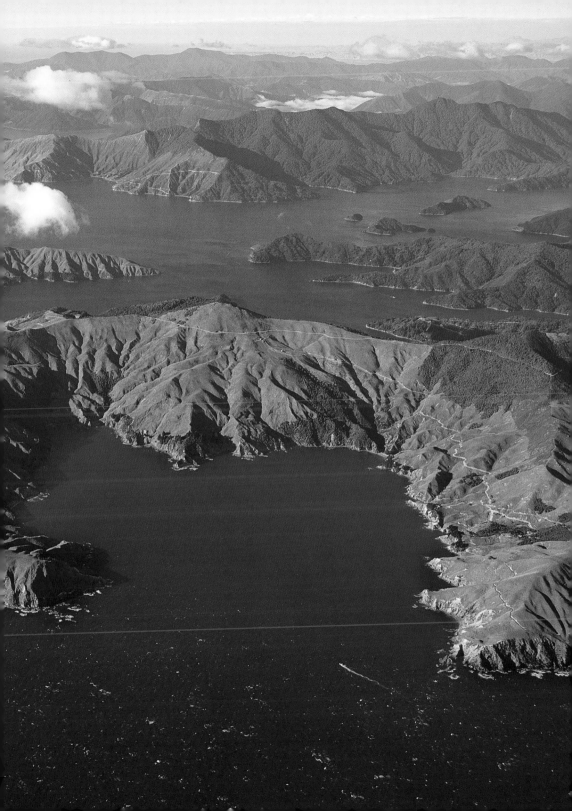

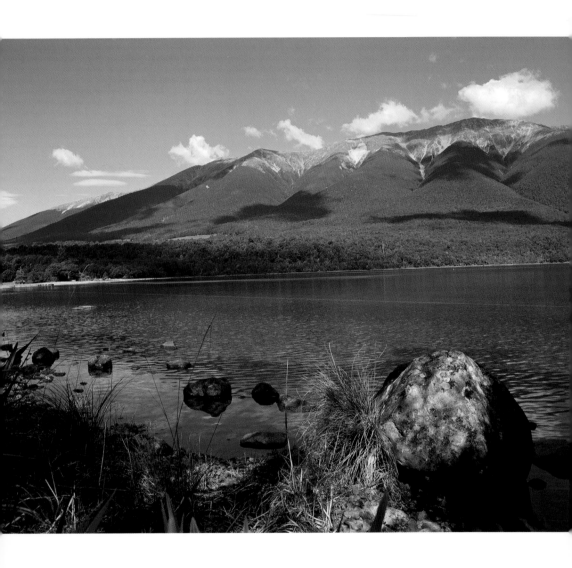

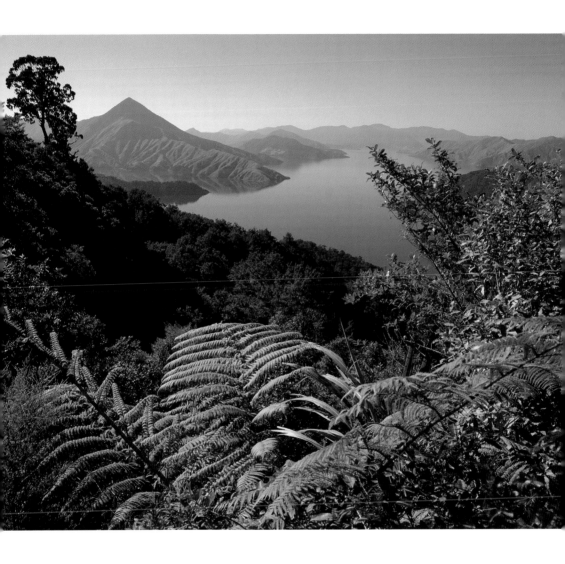

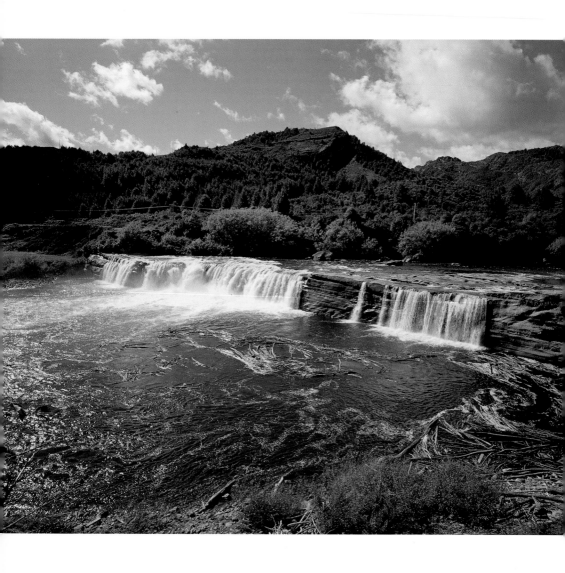

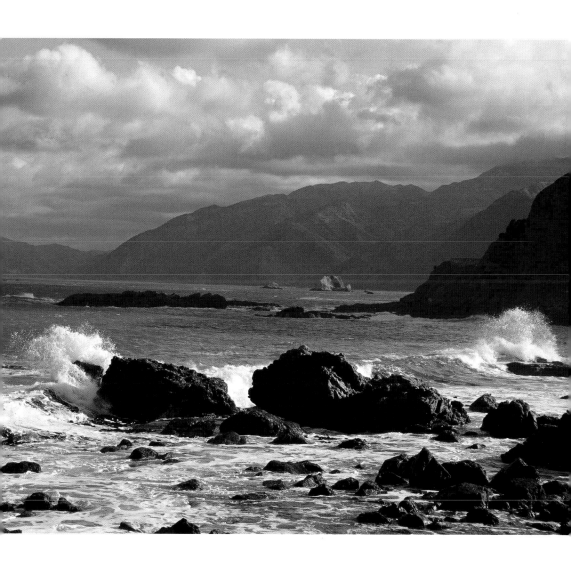

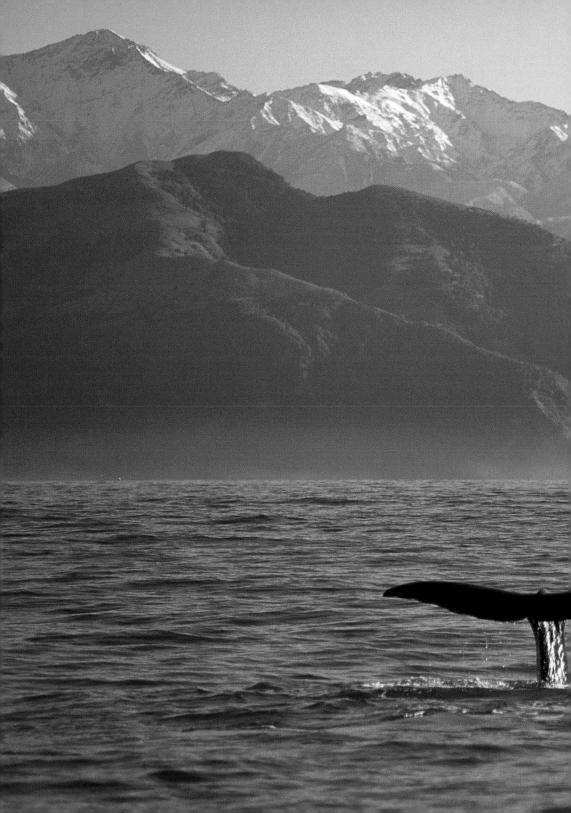

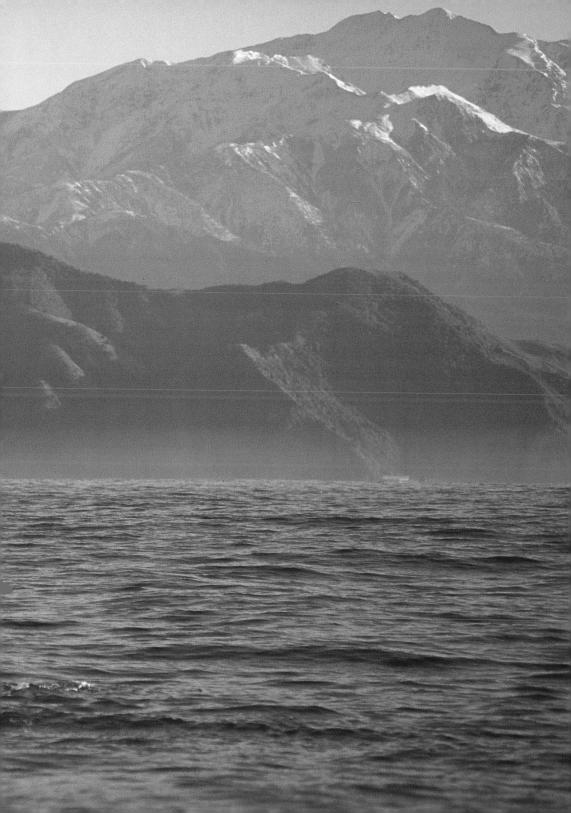

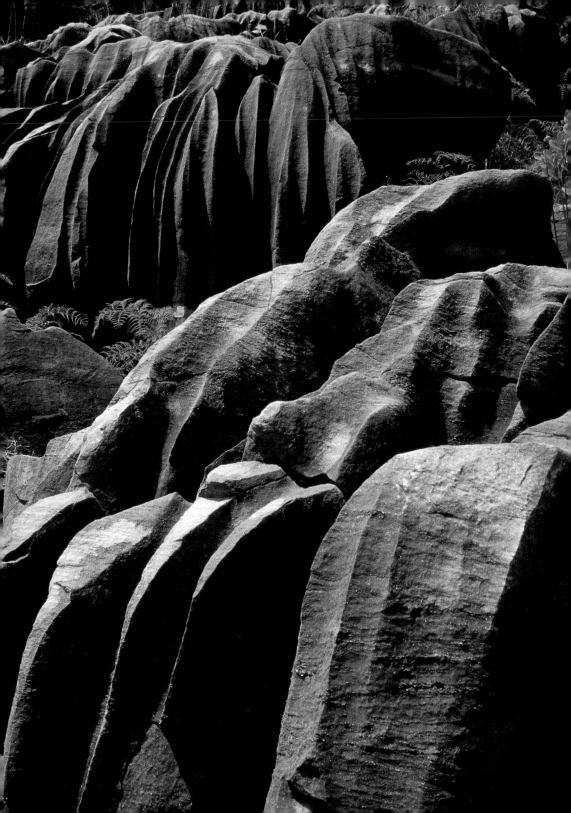

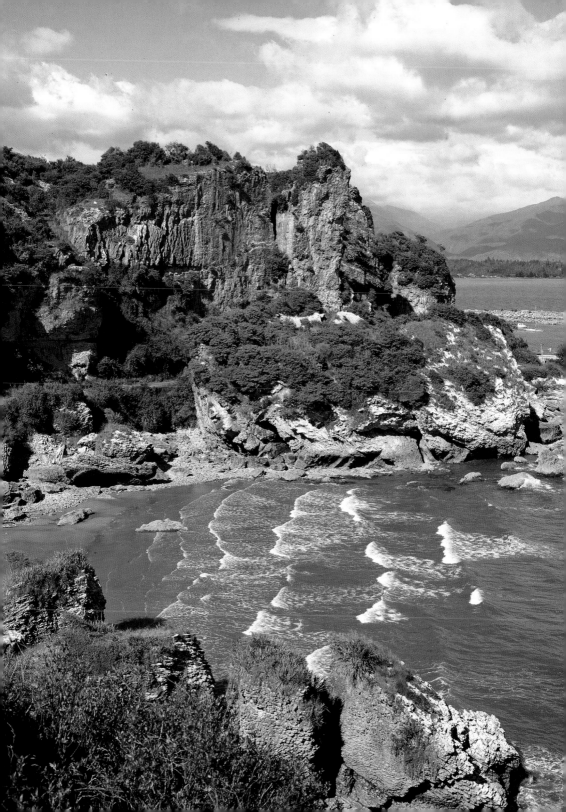

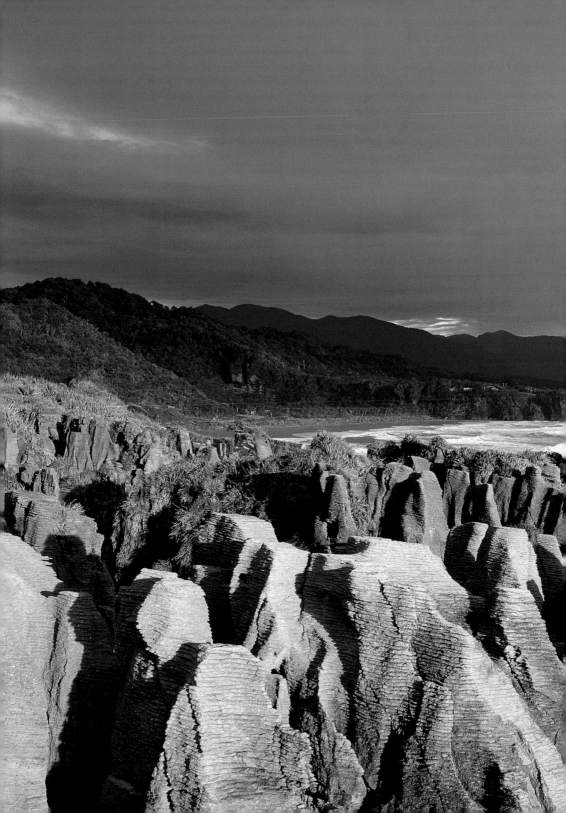

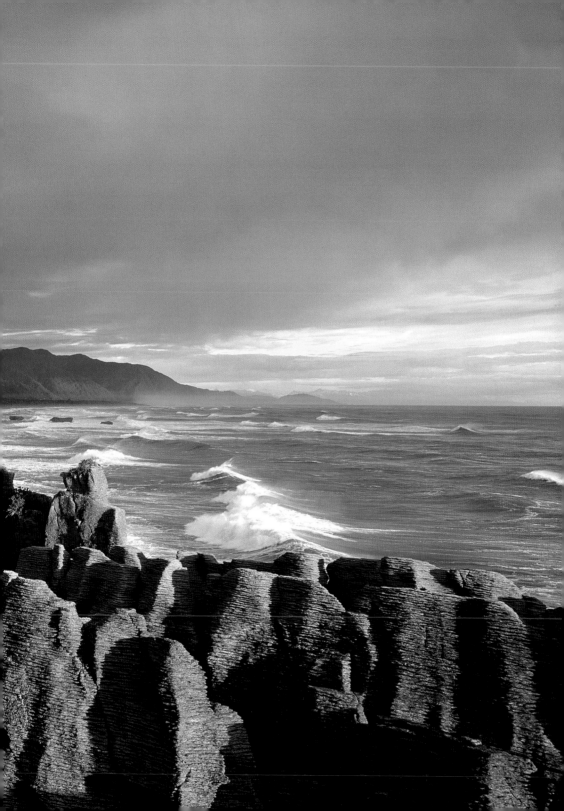

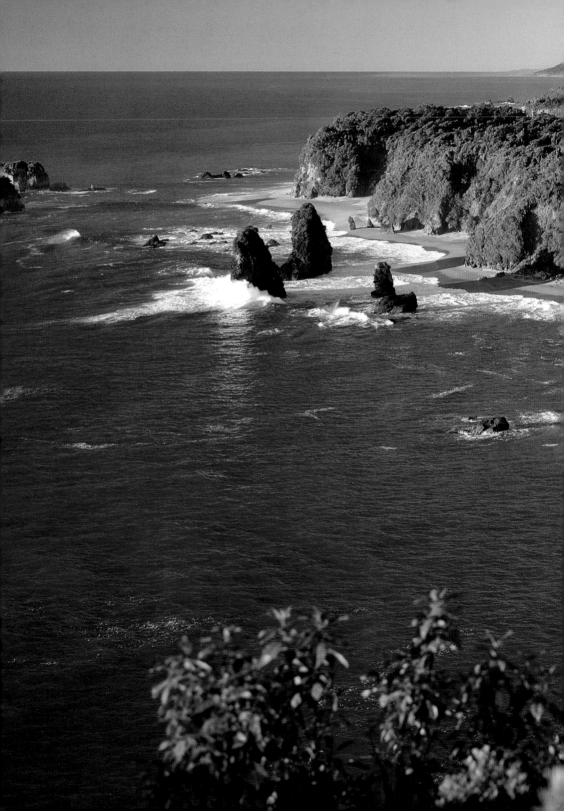

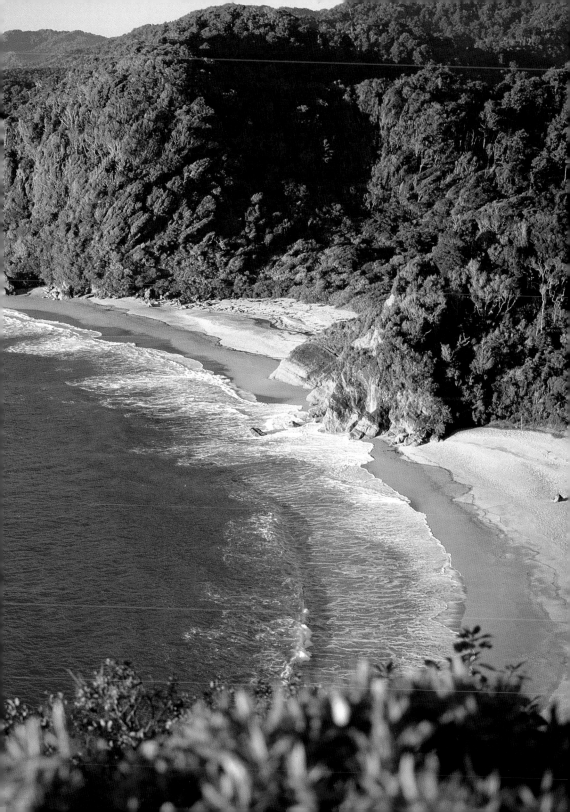

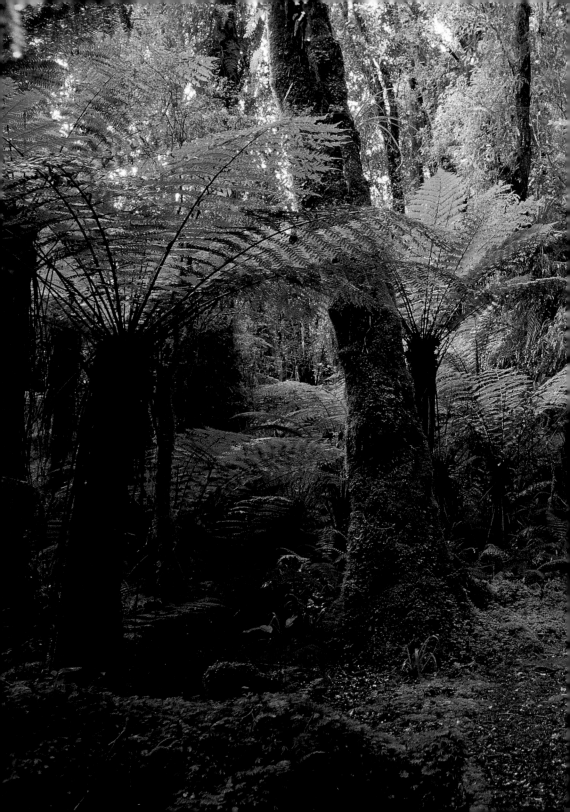

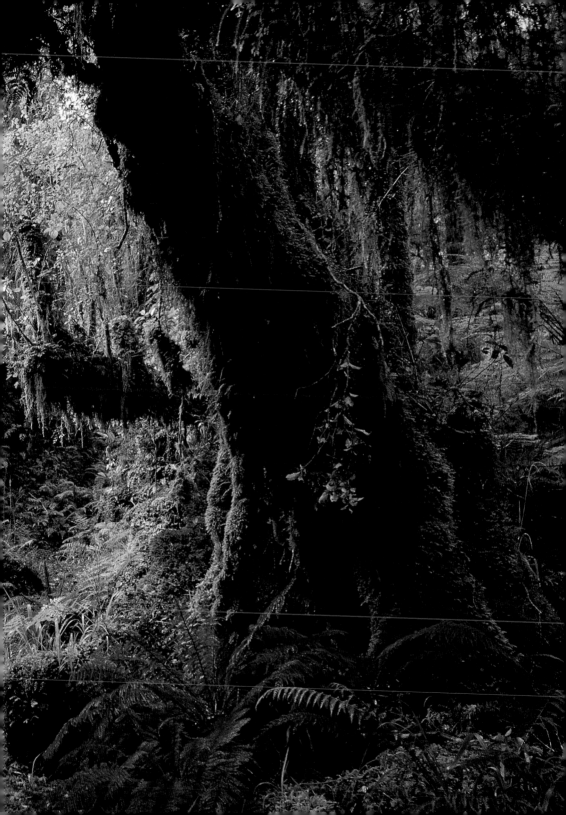

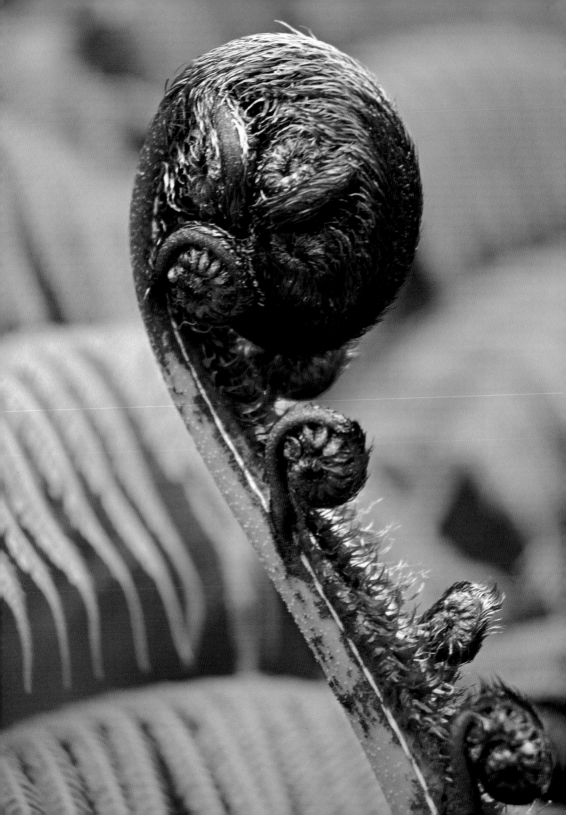

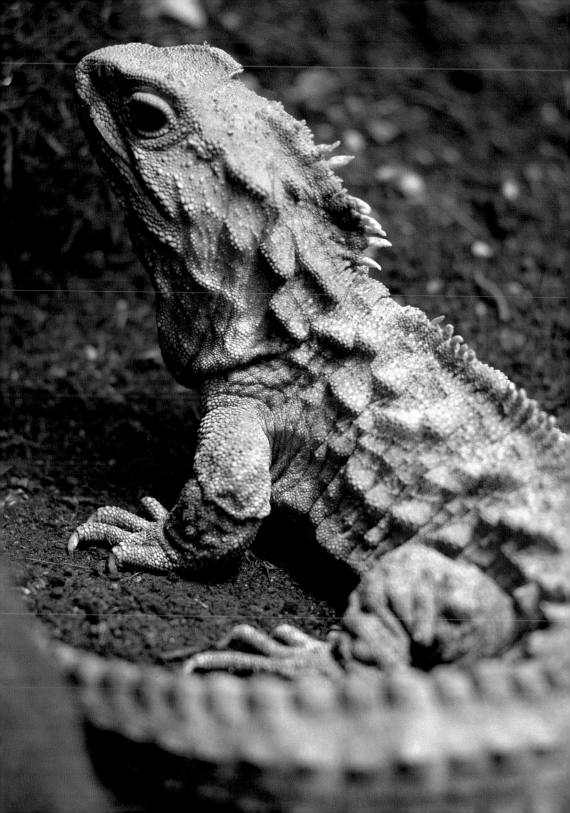

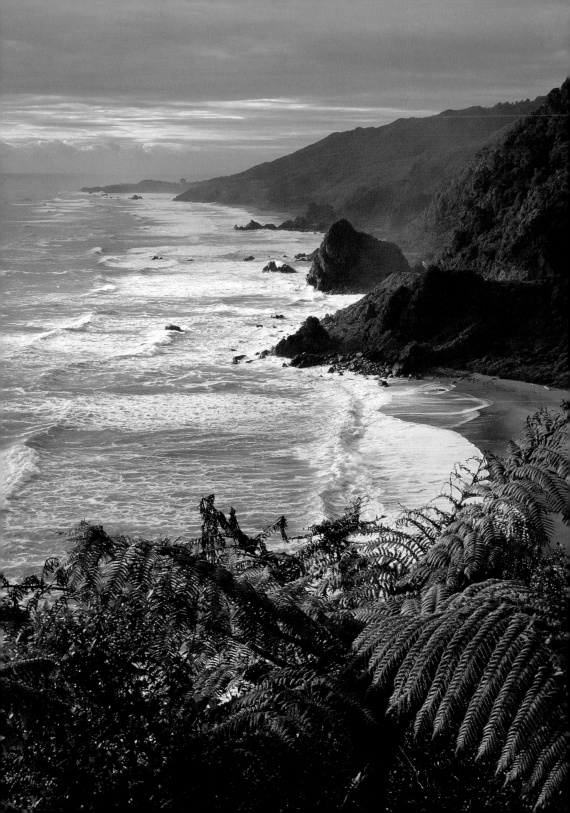

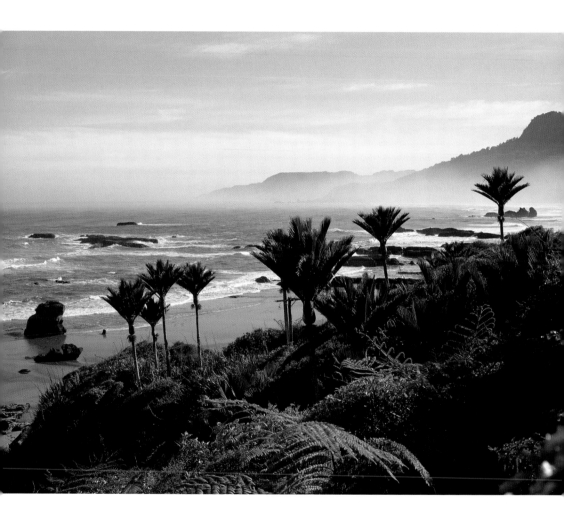

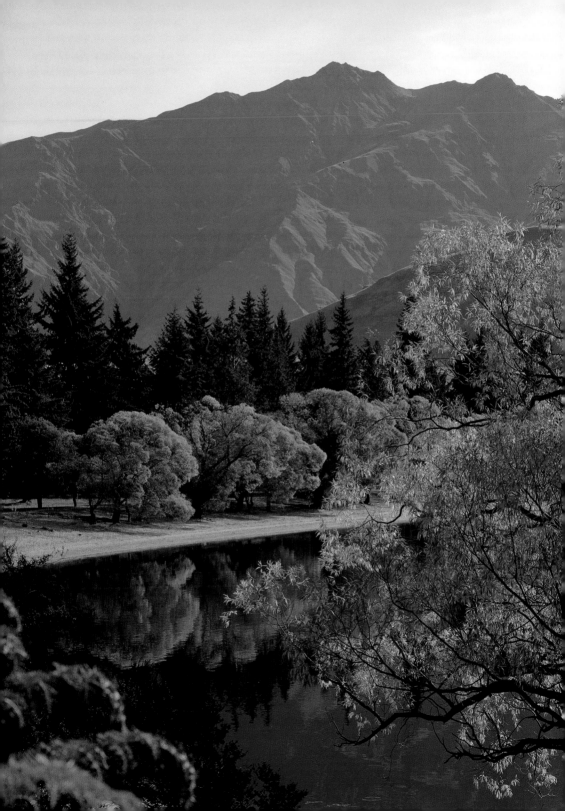

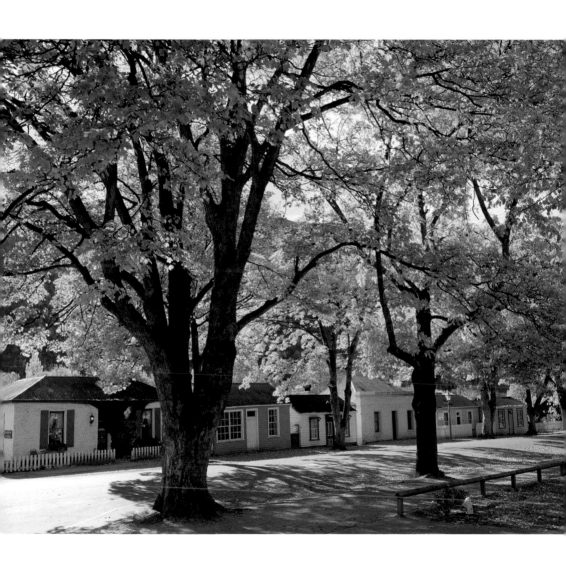

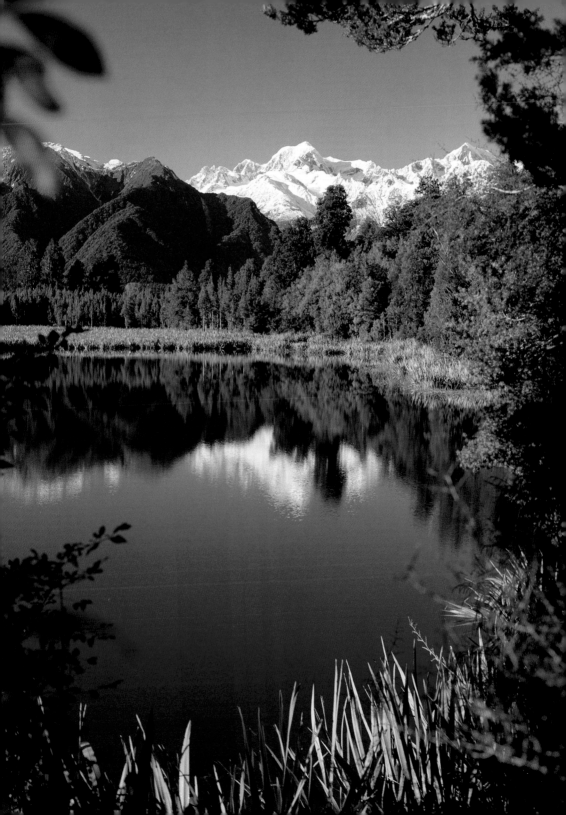

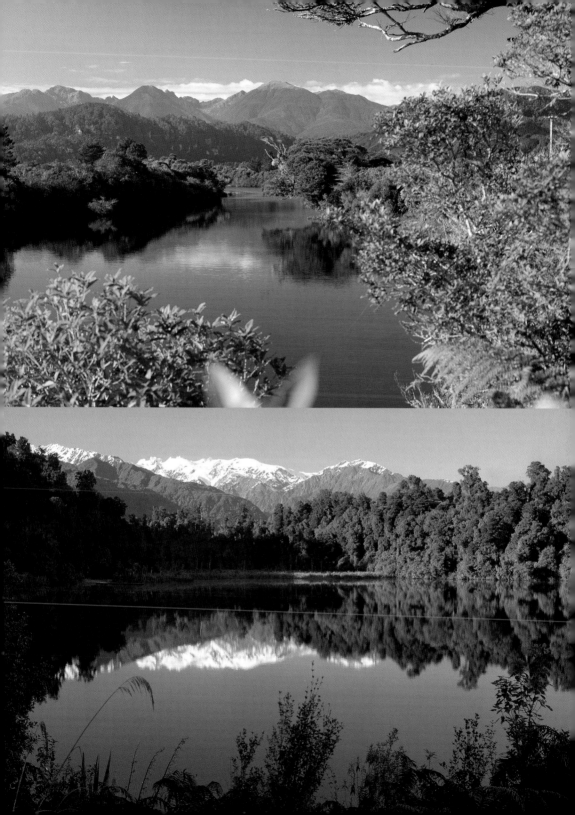

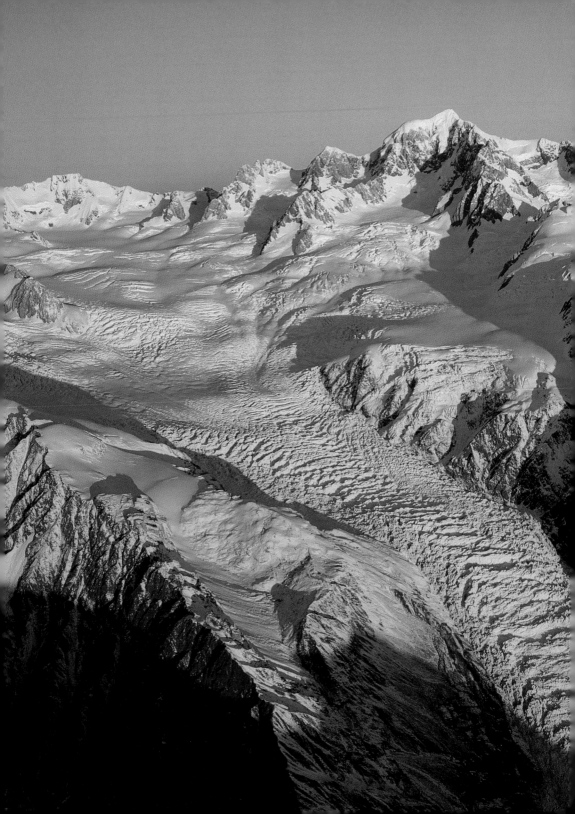

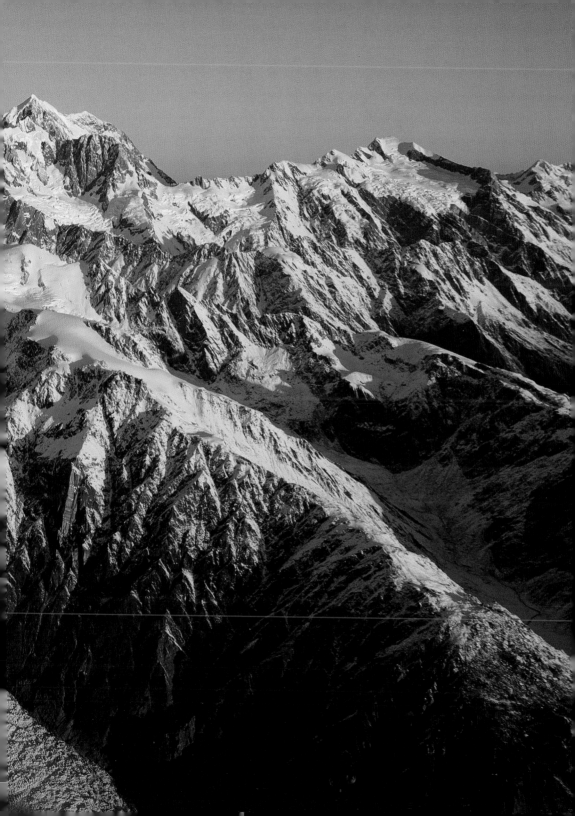

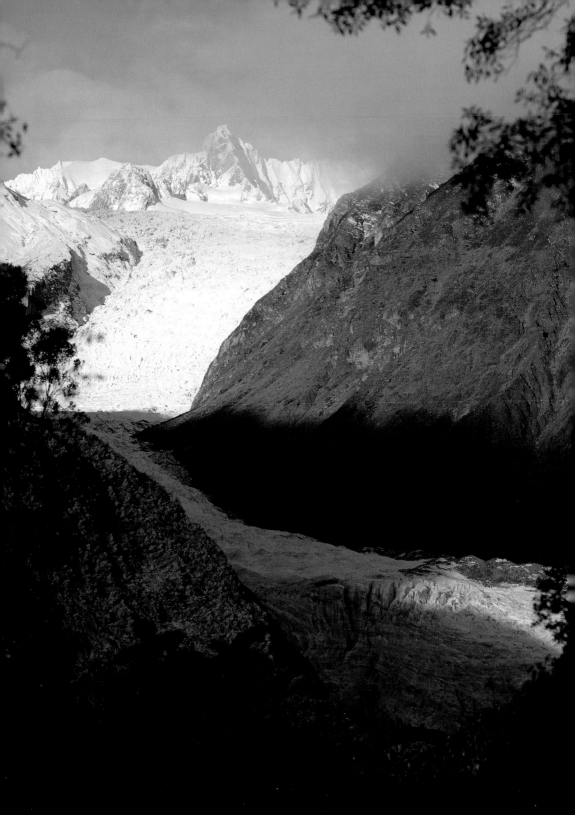

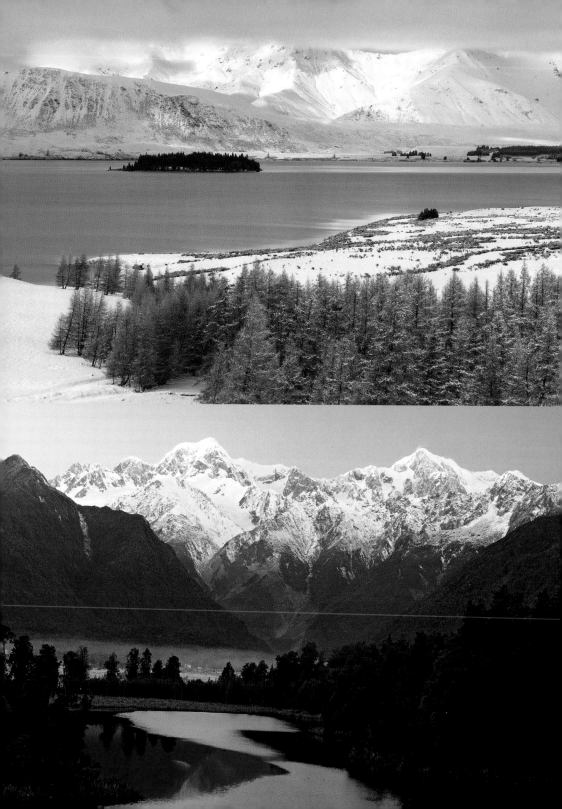

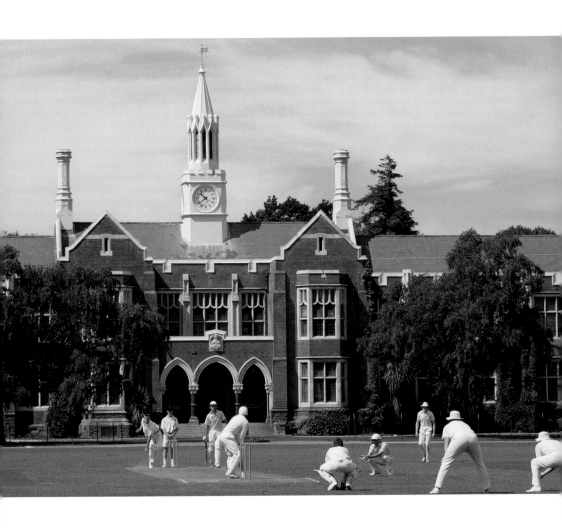

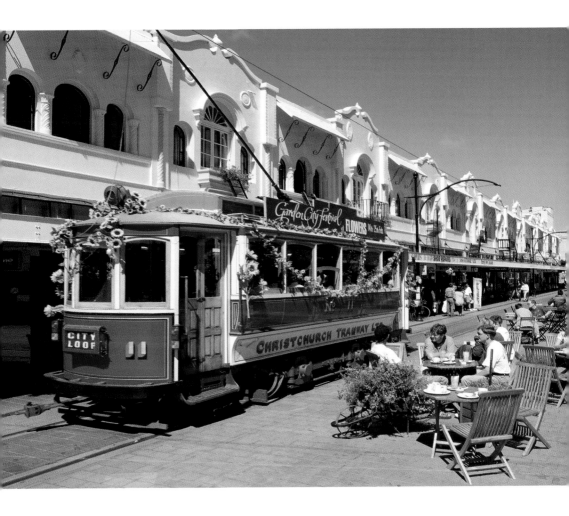

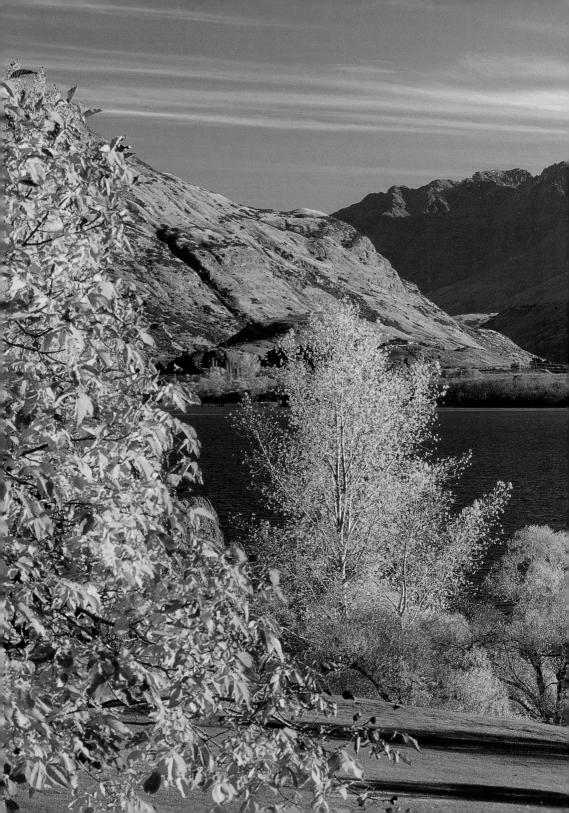

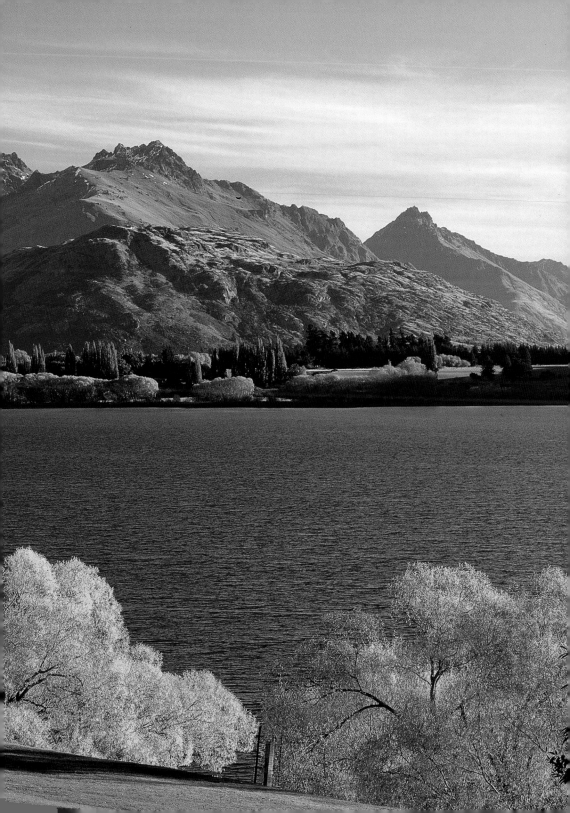

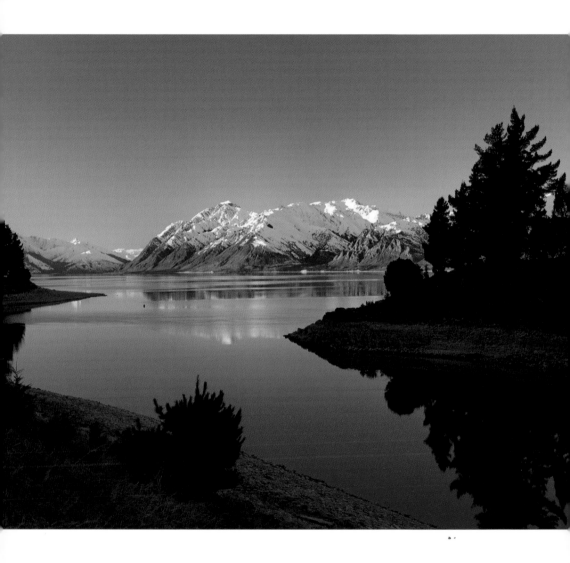

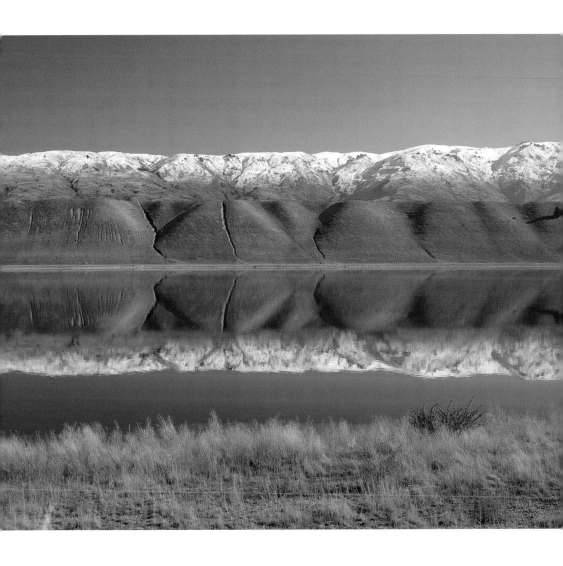

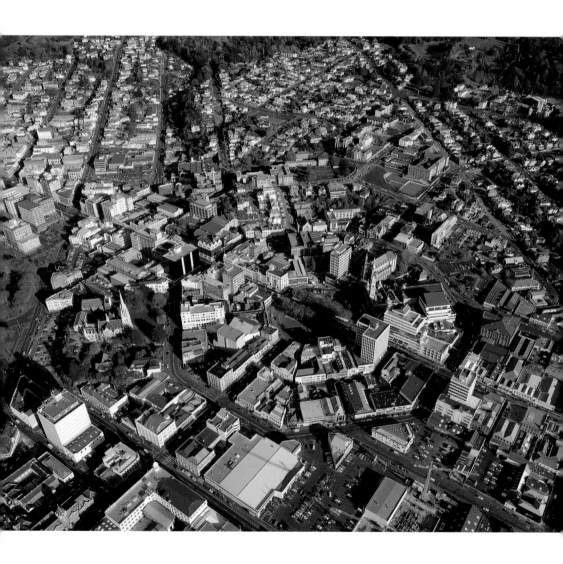

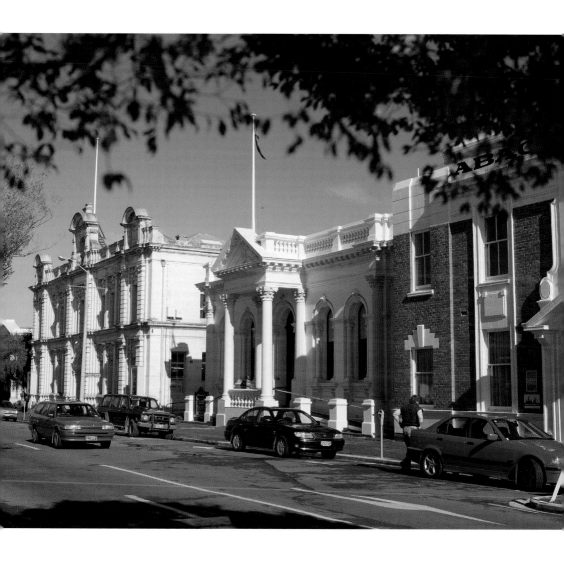

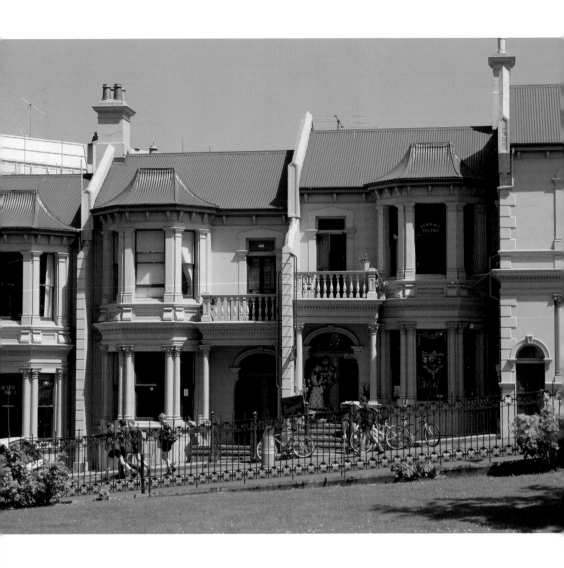

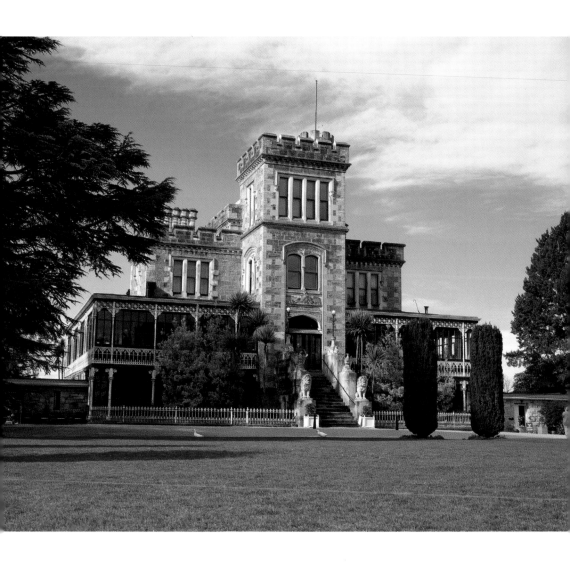

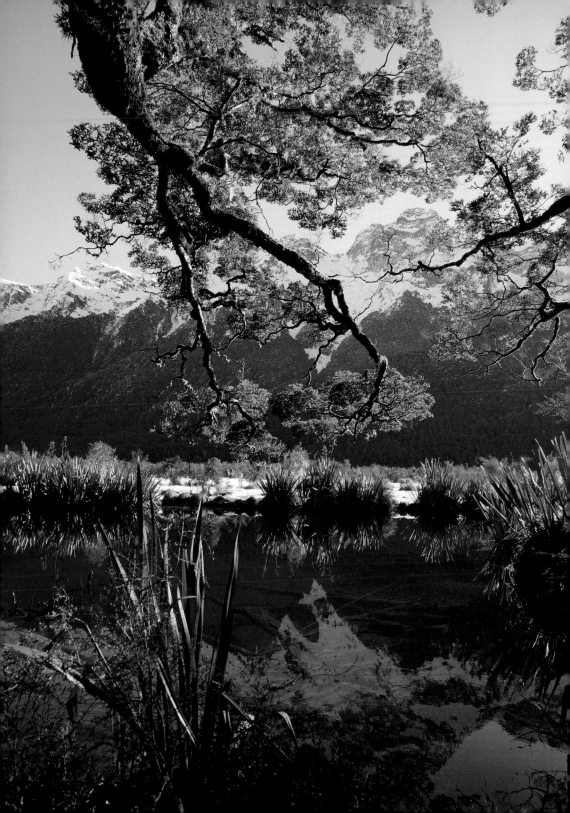

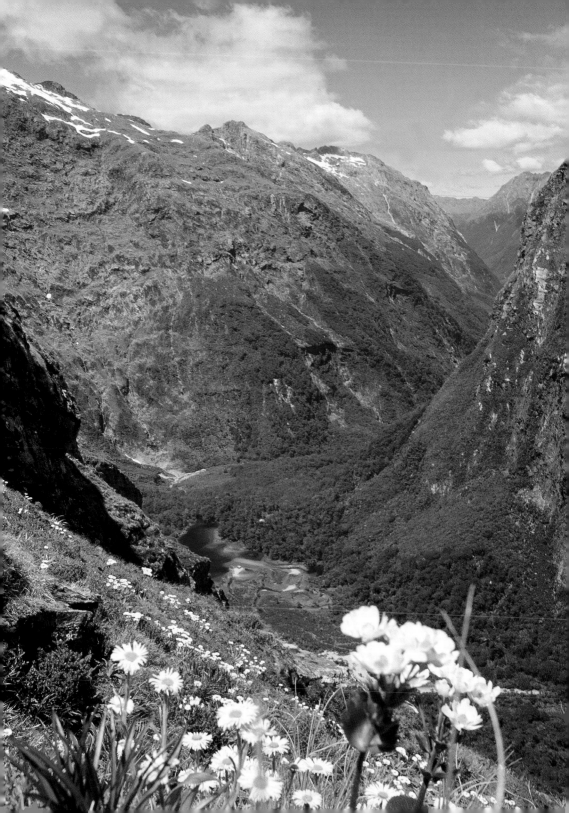

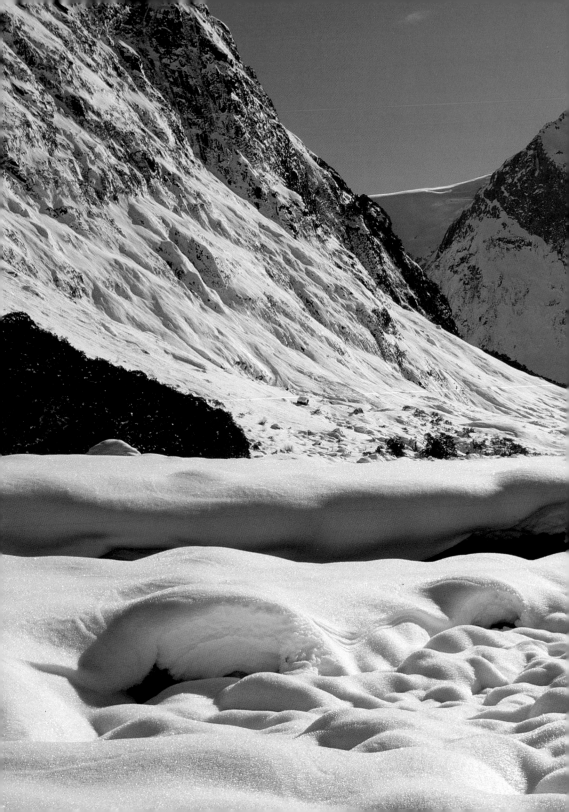

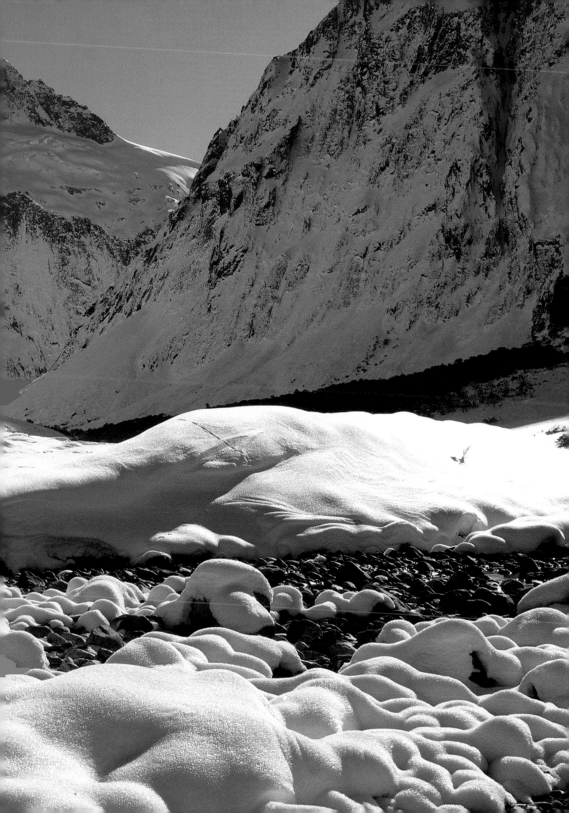

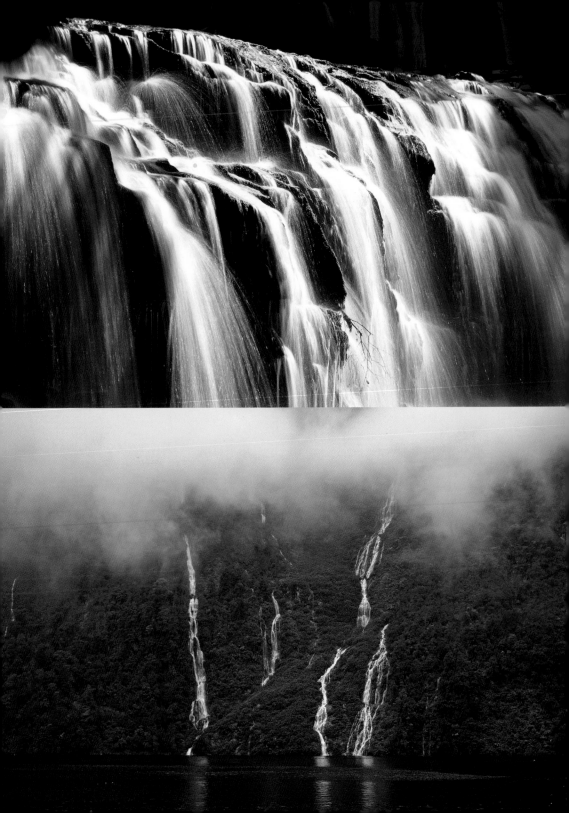

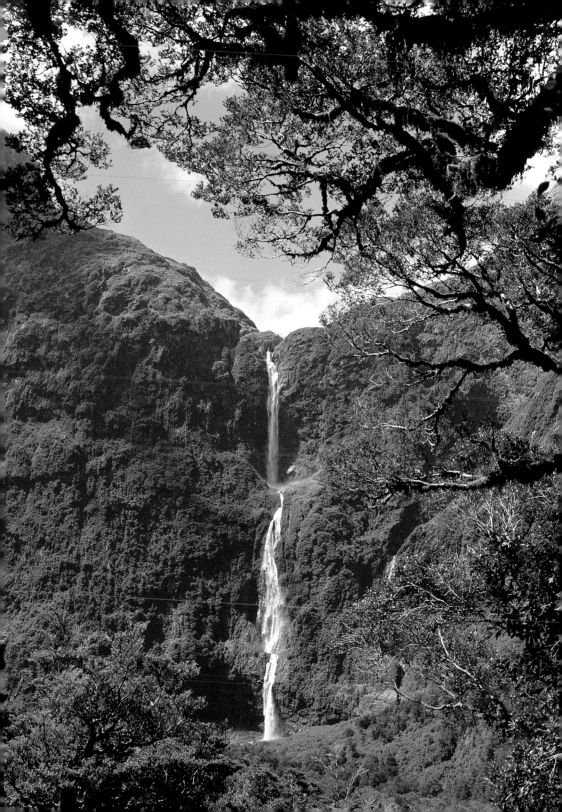

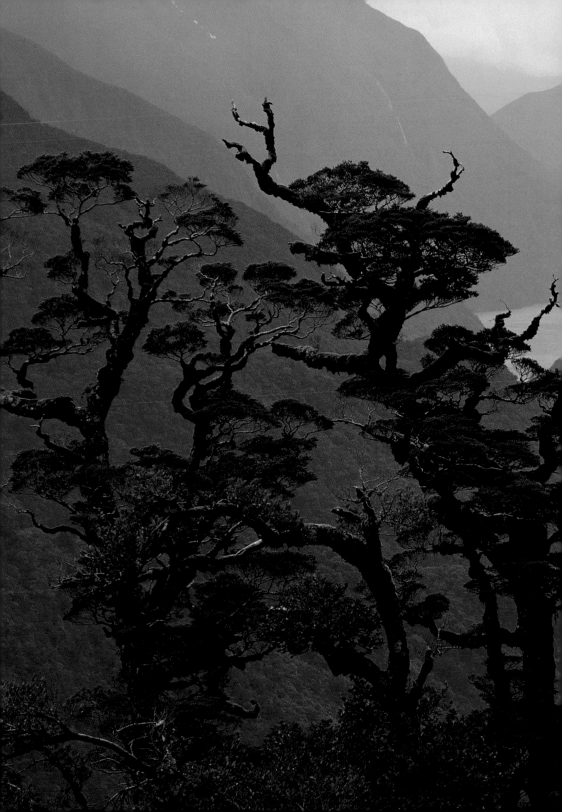

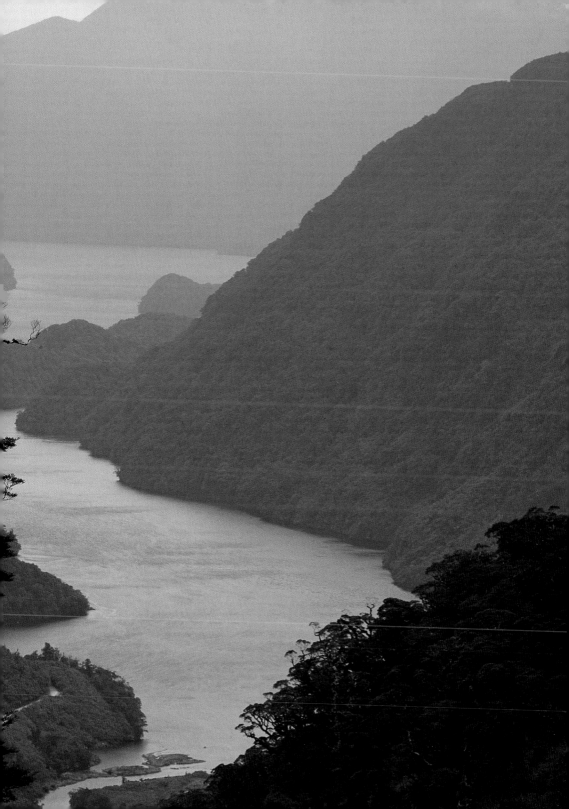

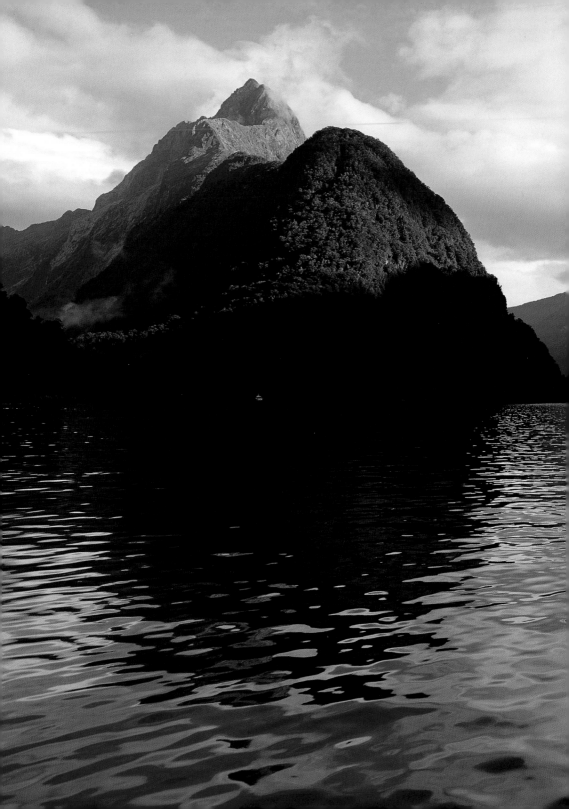

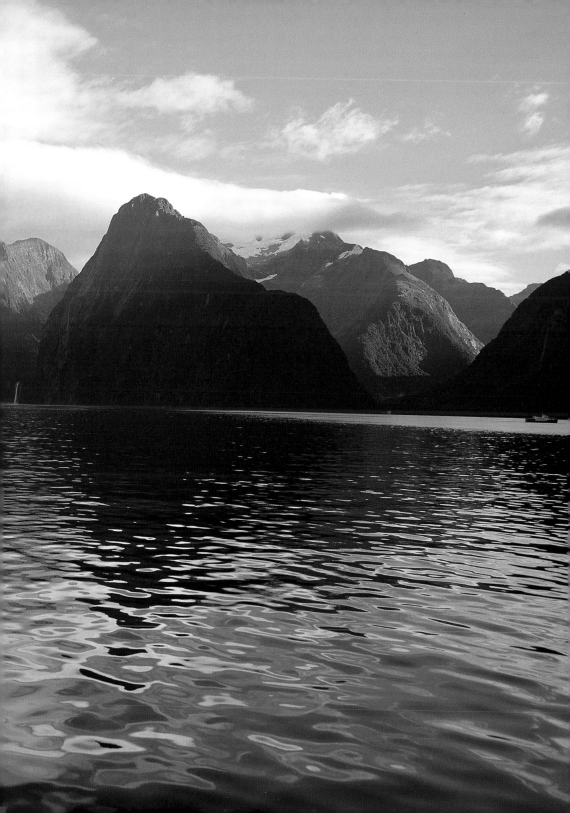

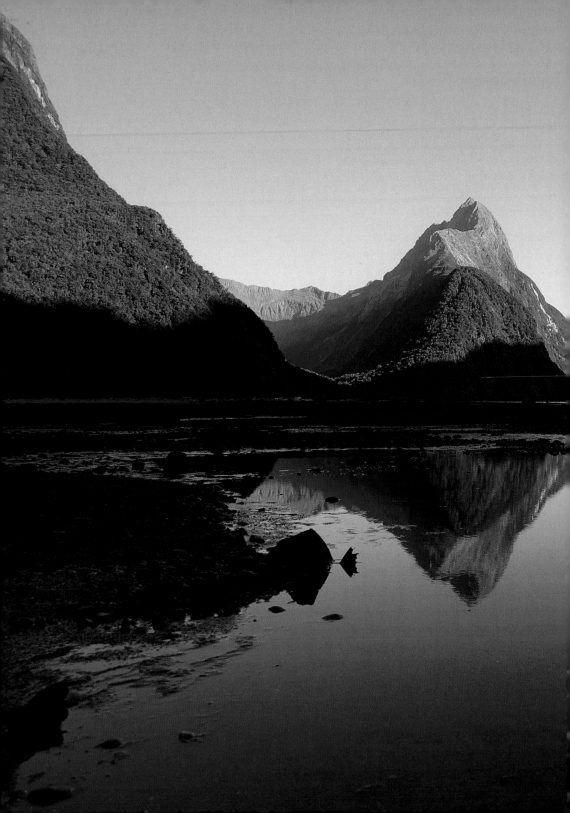

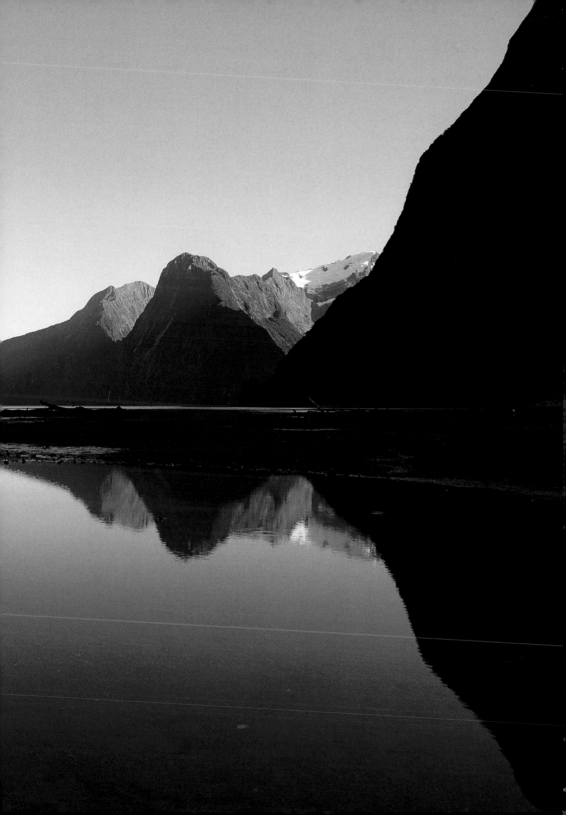

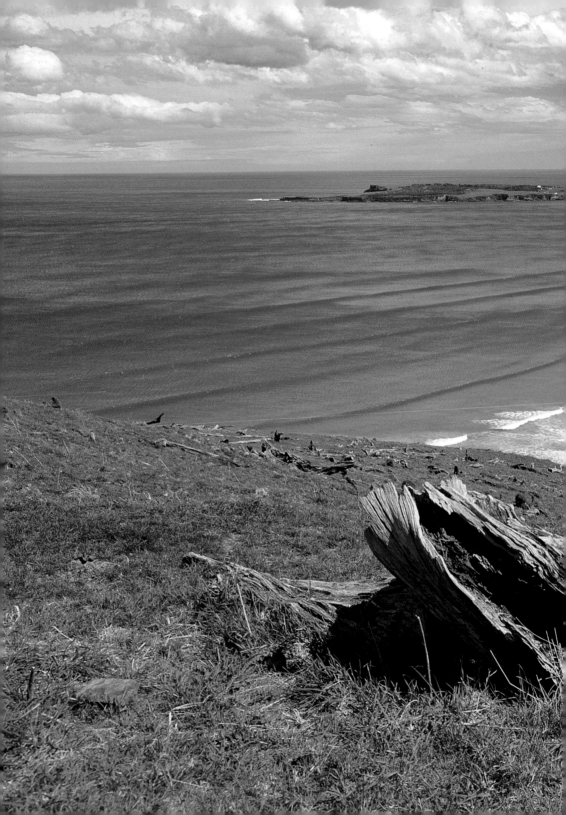

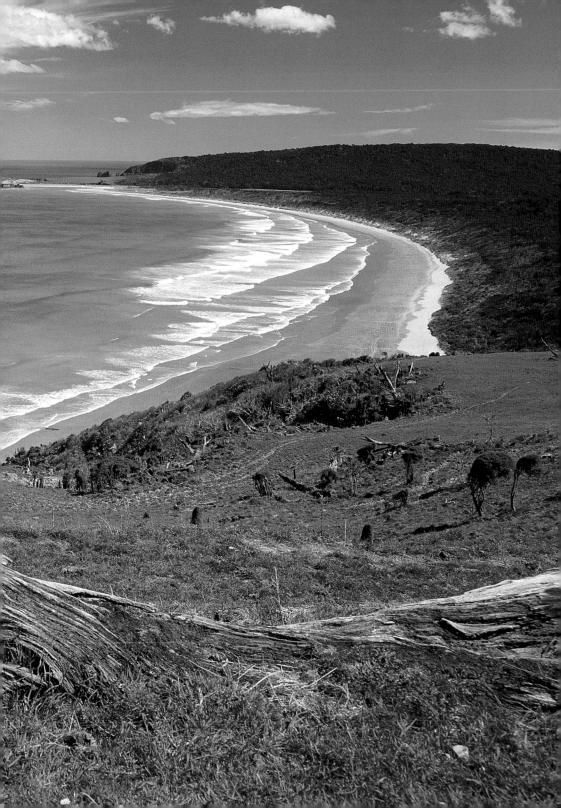

Directory Verzeichnis Table des matières Directorio Indice delle materie

New Zealand

New Zealand / South Island

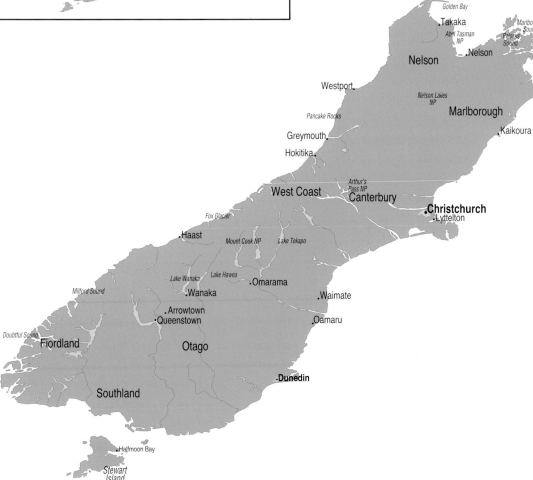

Golden Bay
Takaka
Abel Tasman NP
Marlboro Soun
Pelorus Sound
Nelson
.Nelson
Westport.
Nelson Lakes NP
Marlborough
Pancake Rocks
.Kaikoura
Greymouth.
Hokitika.
Arthur's Pass NP
West Coast
Canterbury
.Christchurch
.Lyttelton
Fox Glacier
Haast
Mount Cook NP
Lake Tekapo
Lake Wanaka
Lake Hawea
.Omarama
Milford Sound
.Wanaka
.Waimate
.Arrowtown
.Queenstown
.Oamaru
Doubtful Sound
Fiordland
Otago
.Dunedin
Southland
.Halfmoon Bay
Stewart Island

New Zealand / North Island

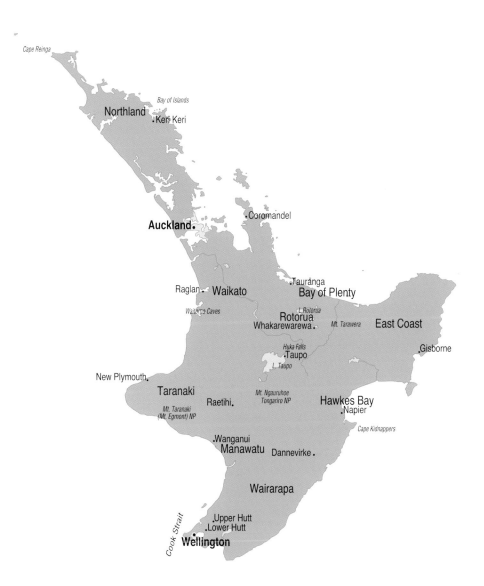

Cape Reinga

Bay of Islands

Northland
.Keri Keri

.Coromandel

Auckland.

.Tauranga
Raglan . Waikato Bay of Plenty

Waitomo Caves
 L.Rotorua
 Rotorua East Coast
 Whakarewarewa. Mt. Tarawera

 Huka Falls Gisborne
 .Taupo
 L. Taupo

New Plymouth.
 Taranaki
 Raetihi. Mt. Ngauruhoe Hawkes Bay
 Mt. Taranaki Tongariro NP .Napier
 (Mt. Egmont) NP

 .Wanganui
 Manawatu Dannevirke .
 Cape Kidnappers

 Wairarapa

 .Upper Hutt
 .Lower Hutt
 .Wellington

Cook Strait

Front cover: Lake Mangamahoe,
　　　　　　Mount Egmont, Taranaki
Back cover: White Island, Bay of Plenty / Auckland /
　　　　　　Lake Hayes / Mitre Peak, Milford Sound

Photographs © 2005 Warren Jacobs
© 2005 teNeues Verlag GmbH + Co. KG, Kempen
All rights reserved.

Warren Jacobs
1051 Dyers Pass Road
Governors Bay
RD1. Lyttelton
New Zealand
Phone: 0064-(0)3-329 90 48
e-mail: swjacobs@cyberxpress.co.nz

Photographs by Warren Jacobs
Design by Mario Moths
Introduction by John Wilson
Translation by SAW Communications,
Dr. Sabine A. Werner, Mainz
Dr. Sabine A. Werner (German)
Céline Verschelde (French)
Silvia Gómez de Antonio (Spanish)
Elena Nobilini (Italian)
Editorial coordination by Sabine Wagner
Production by Alwine Krebber
Color separation by Laudert GmbH & Co. KG,
Vreden, Germany

Bibliographic information published by Die Deutsche
Bibliothek. Die Deutsche Bibliothek lists this publica-
tion in the Deutsche Nationalbibliographie; detailed
bibliographic data is available in the Internet at
http://dnb.ddb.de

ISBN 3-8327-9086-1

Printed in Italy

teNeues Publishing Group
Kempen
Düsseldorf
London
Madrid
New York
Paris

Published by teNeues Publishing Group

teNeues Book Division
Kaistraße 18
40221 Düsseldorf
Germany
Phone: 00 49-(0)2 11-99 45 97-0
Fax: 00 49-(0)2 11-99 45 97-40
e-mail: books@teneues.de
Press department: arehn@teneues.de
Phone: 00 49-(0) 21 52-916-202

teNeues Publishing Company
16 West 22nd Street
New York, N.Y. 10010
USA
Phone: 001-212-627-9090
Fax: 001-212-627-9511

teNeues Publishing UK Ltd.
P.O. Box 402
West Byfleet
KT14 7ZF
Great Britain
Phone: 0044-1932-403509
Fax: 0044-1932-403514

teNeues France S.A.R.L.
4, rue de Valence
75005 Paris
France
Phone: 00 33-1-55 76 62 05
Fax: 00 33-1-55 76 64 19

teNeues Iberica S.L.
Pso. Juan de la Encina 2-48
Urb. Club de Campo
28700 S.S.R.R. Madrid
Spain
Tel/ Fax: +34 (0) 91 65 95 876

www.teneues.com

Published in the same series:

AUSTRALIA	3-8327-9039-X
CALIFORNIA	3-8327-9085-3
GREECE	3-8327-9002-0
IRELAND	3-8327-9001-2
PROVENCE	3-8238-4575-6
TOSCANA	3-8238-4567-5

teNeues

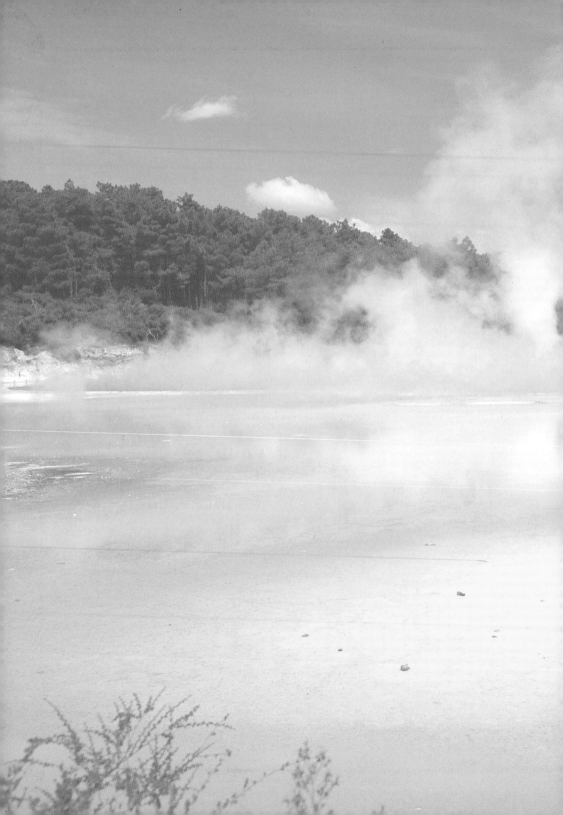